# Paisley Designs

## COLORING BOOK

KELLY A. BAKER, ROBIN J. BAKER
& MARTY NOBLE

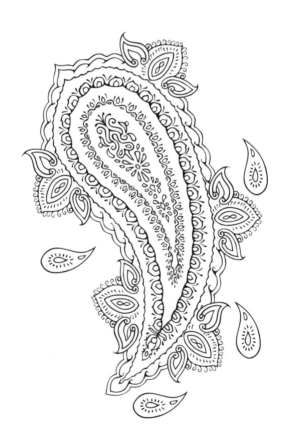

DOVER PUBLICATIONS, INC.
MINEOLA, NEW YORK

*Bibliographical Note*

*Paisley Designs Coloring Book* contains all the plates from the following previously published Dover books: *Crazy Paisley* (designs 1–31) by Kelly A. Baker and Robin J. Baker, and *Paisley Designs Coloring Book* (designs 32–63) by Marty Noble.

*International Standard Book Number*

*ISBN-13: 978-0-486-80355-5*
*ISBN-10: 0-486-80355-4*

Manufactured in the United States by RR Donnelley
80355405    2016
www.doverpublications.com

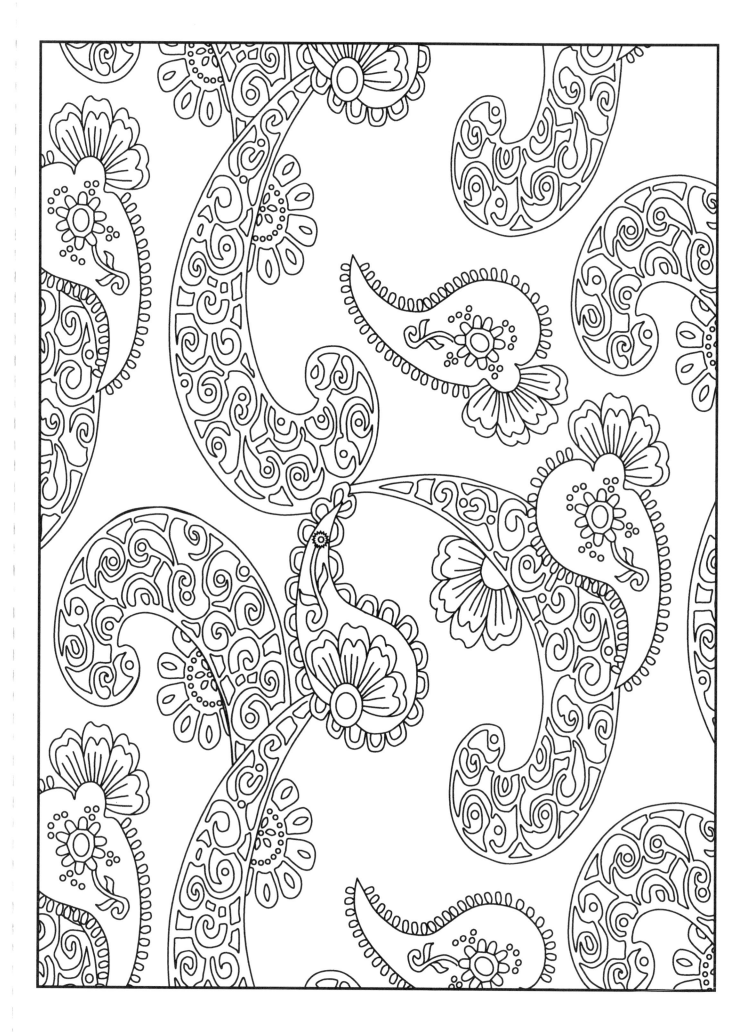

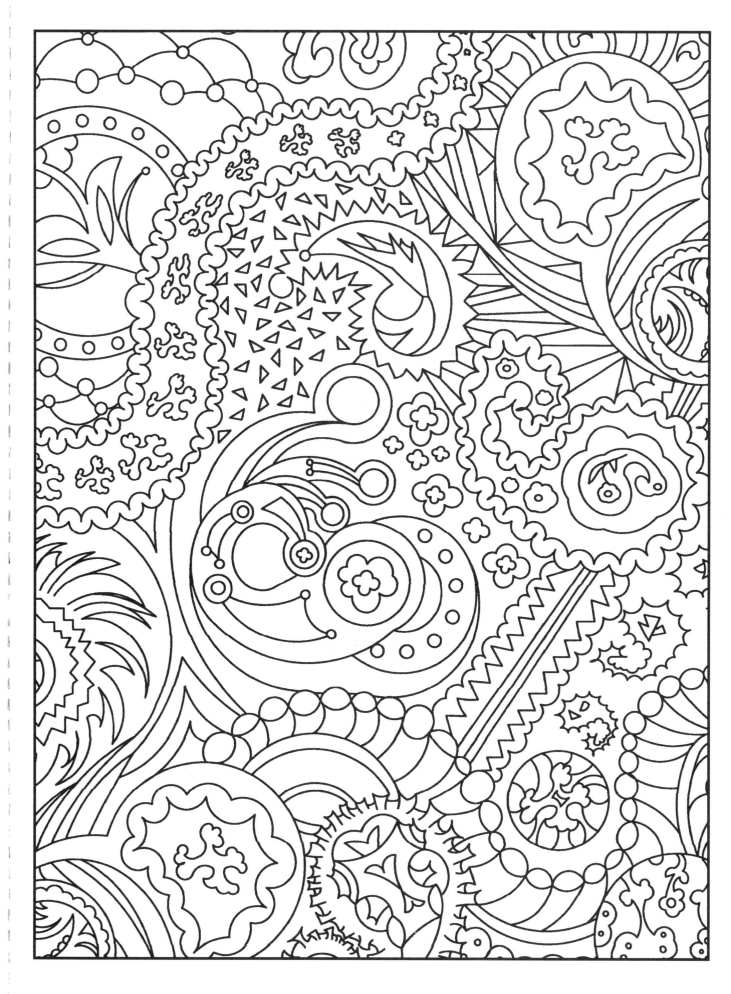

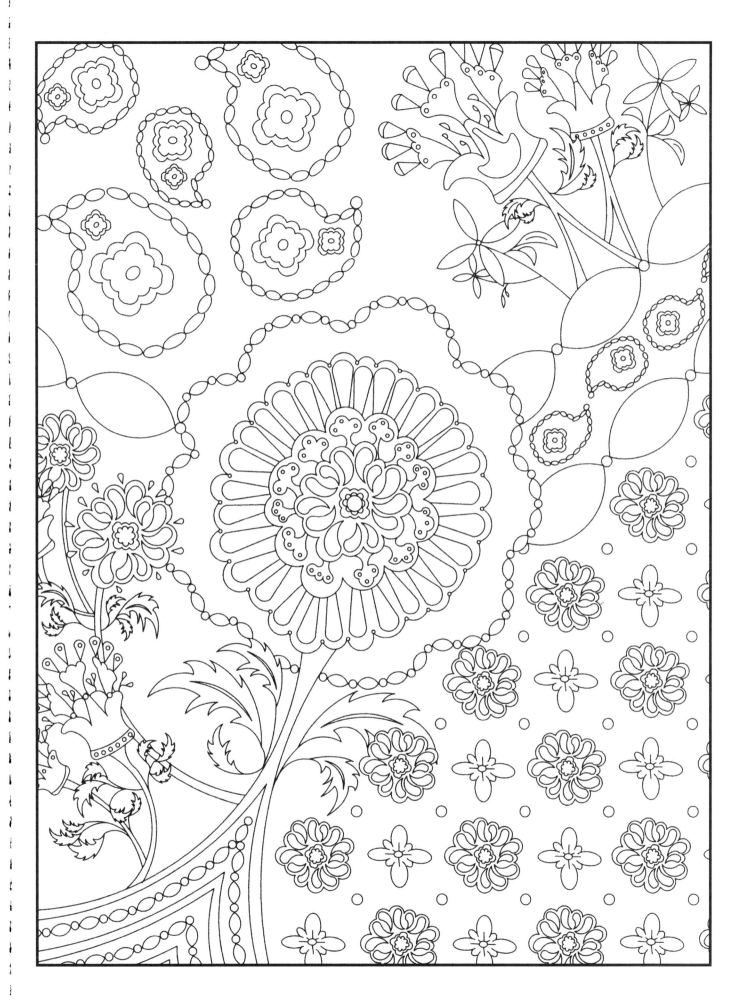

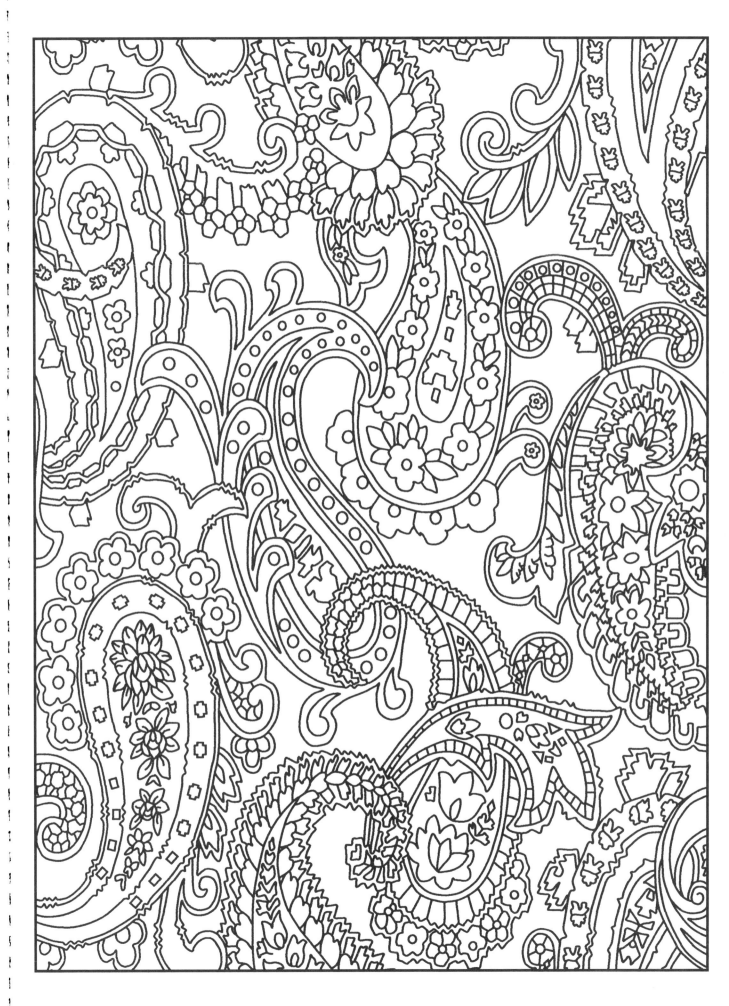

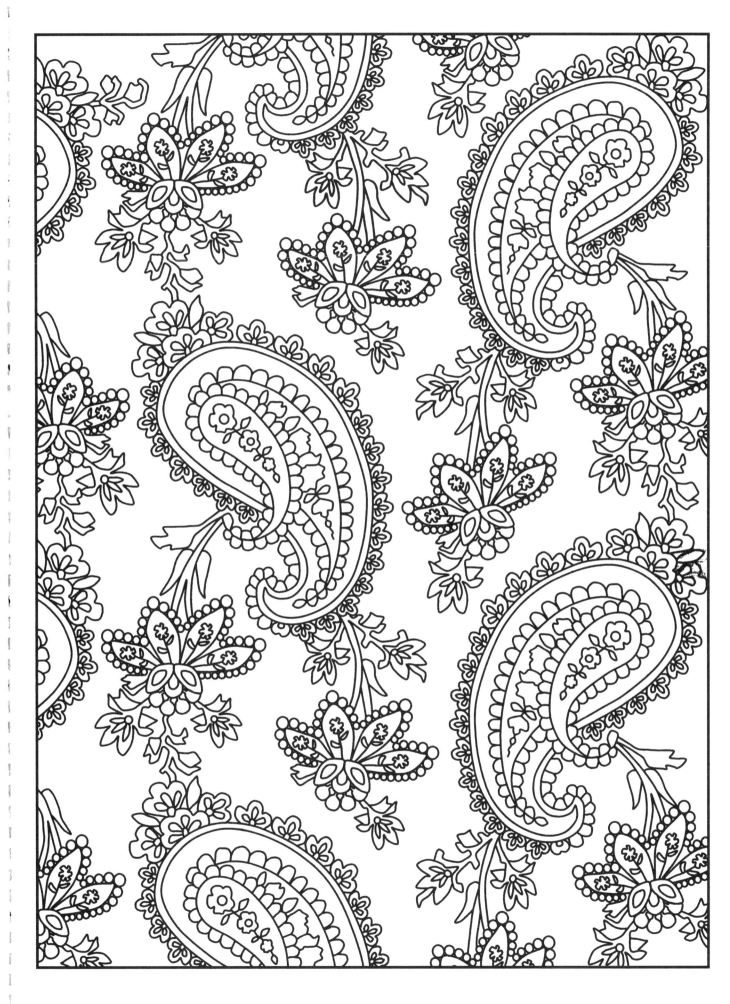

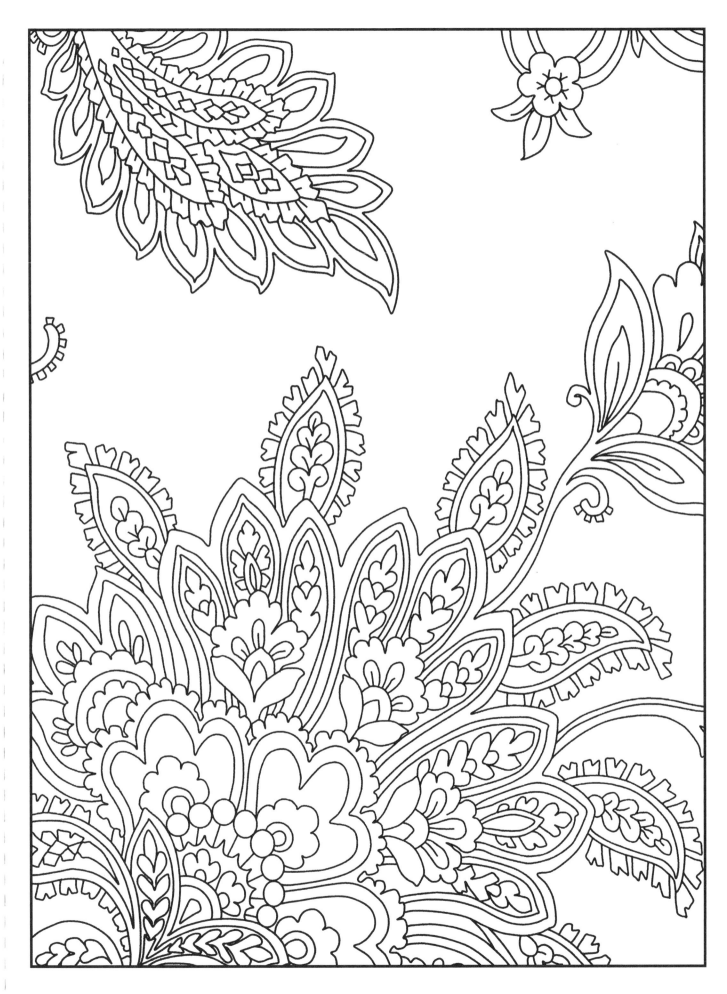

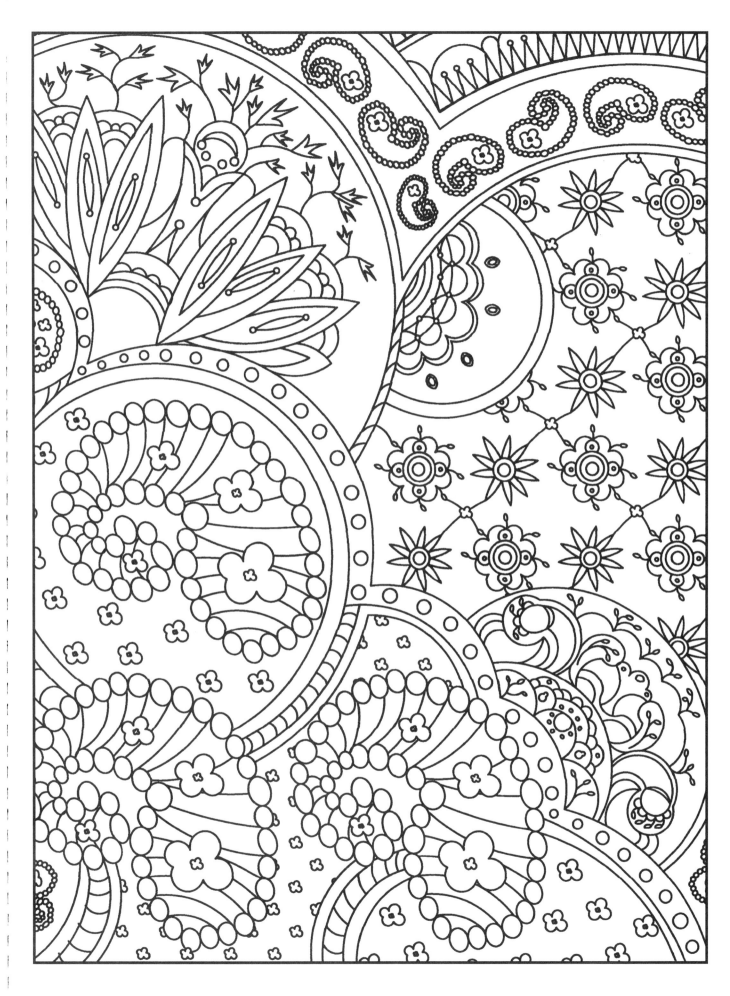

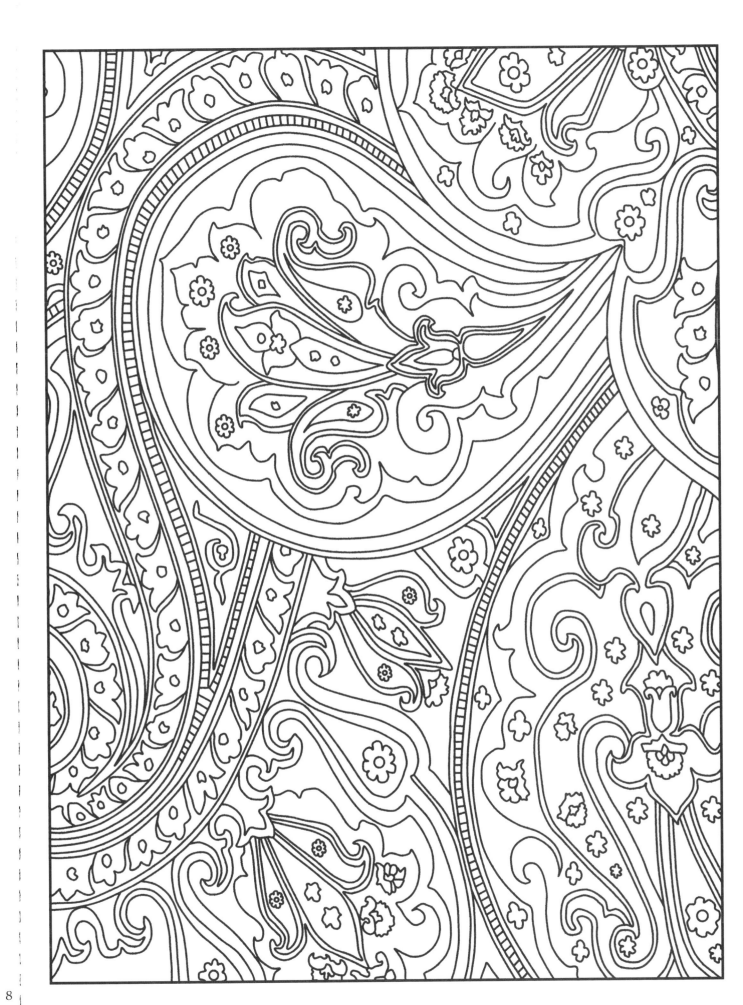

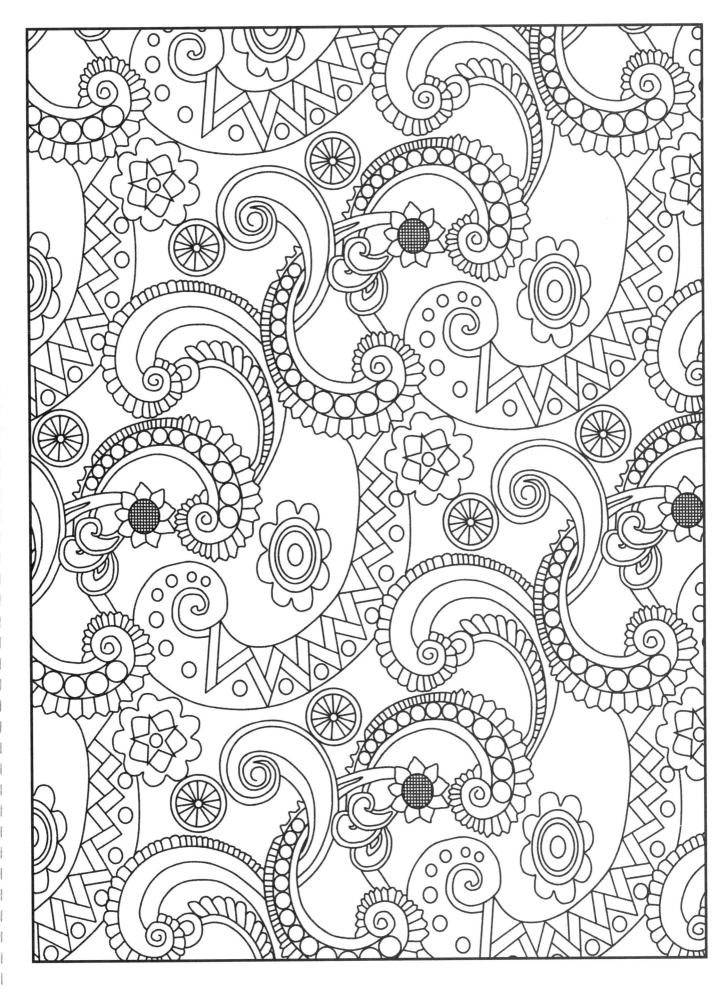

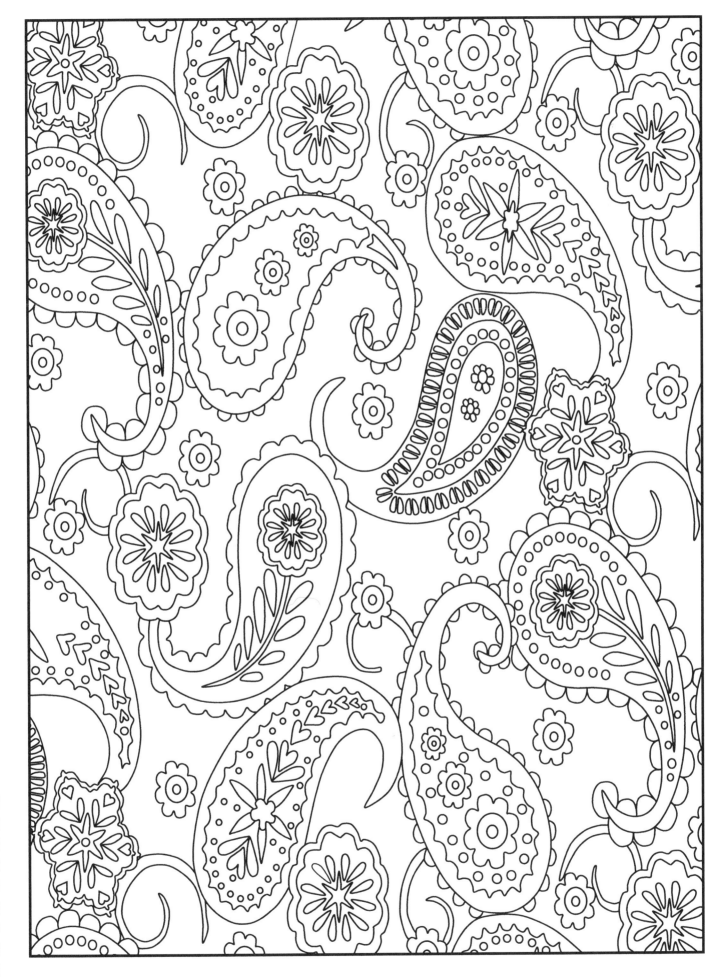

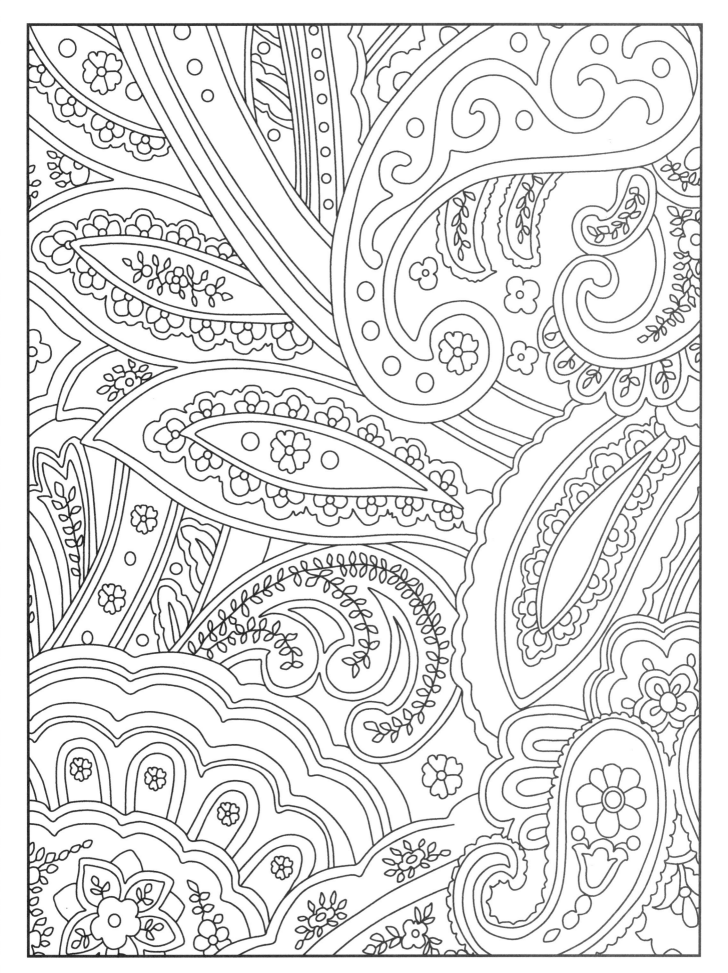

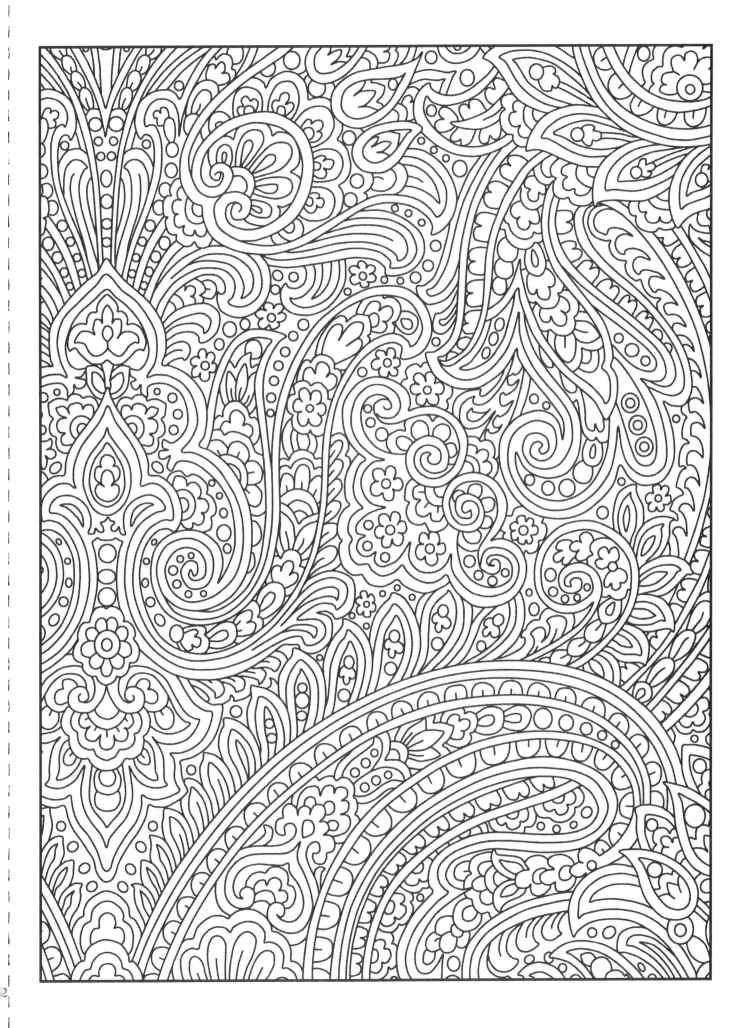

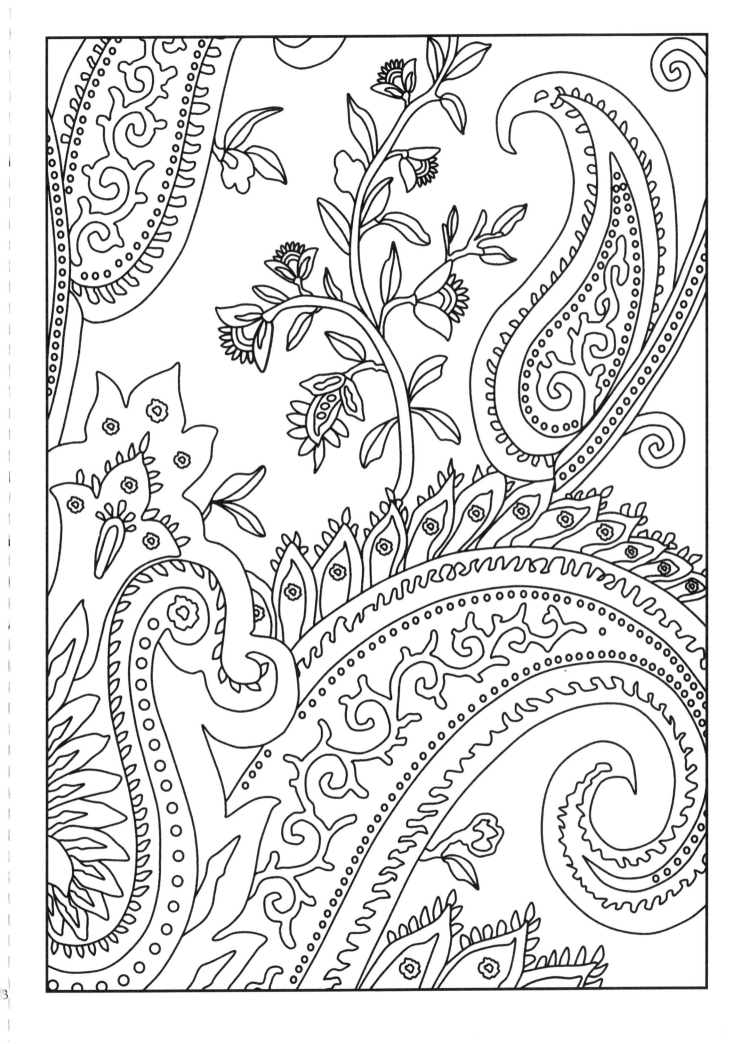

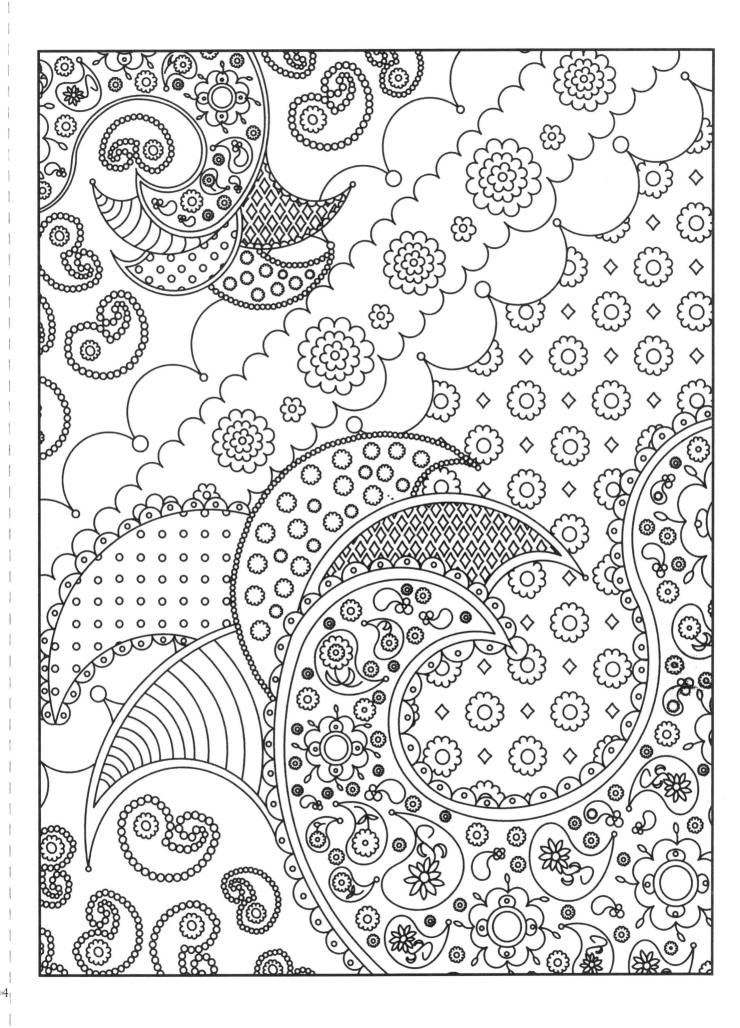

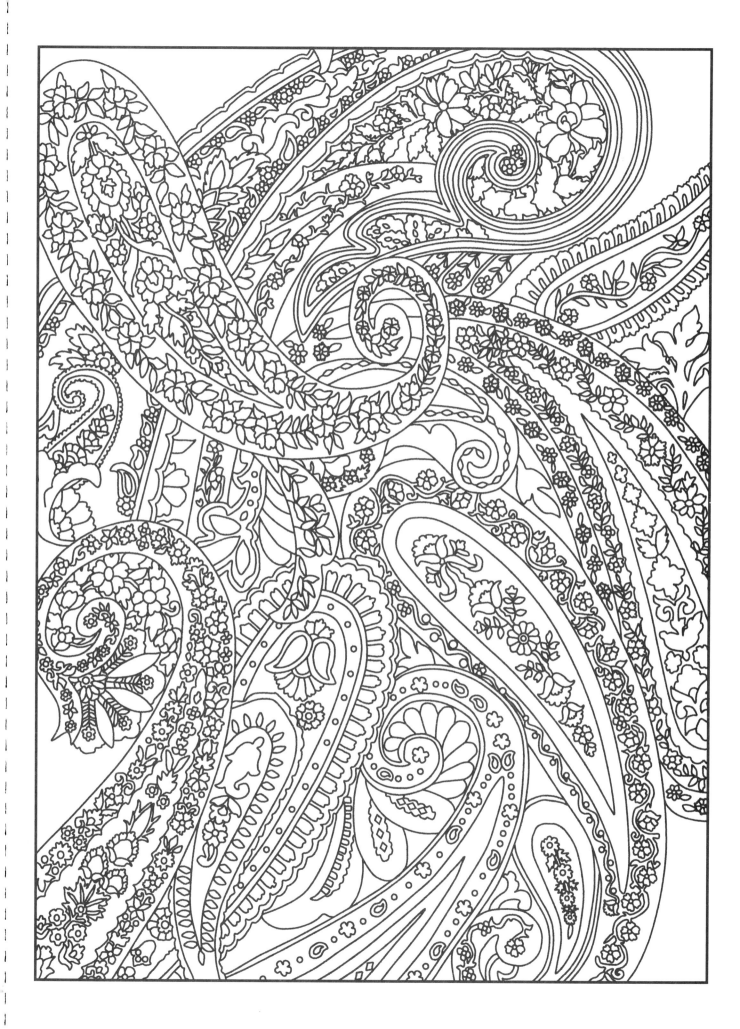

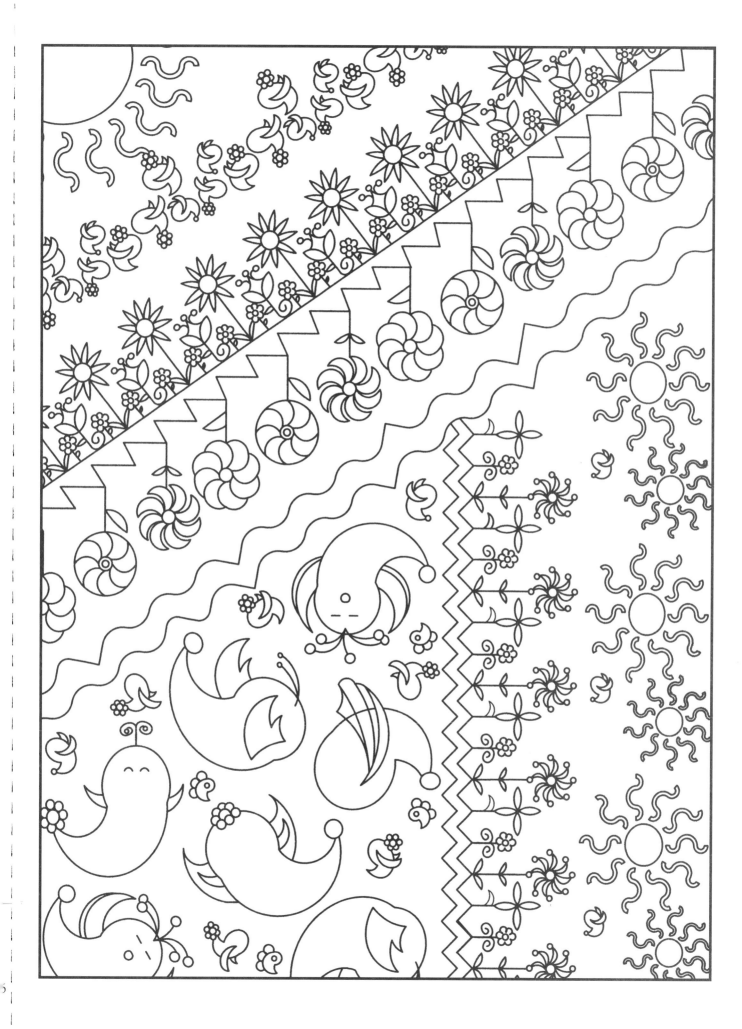

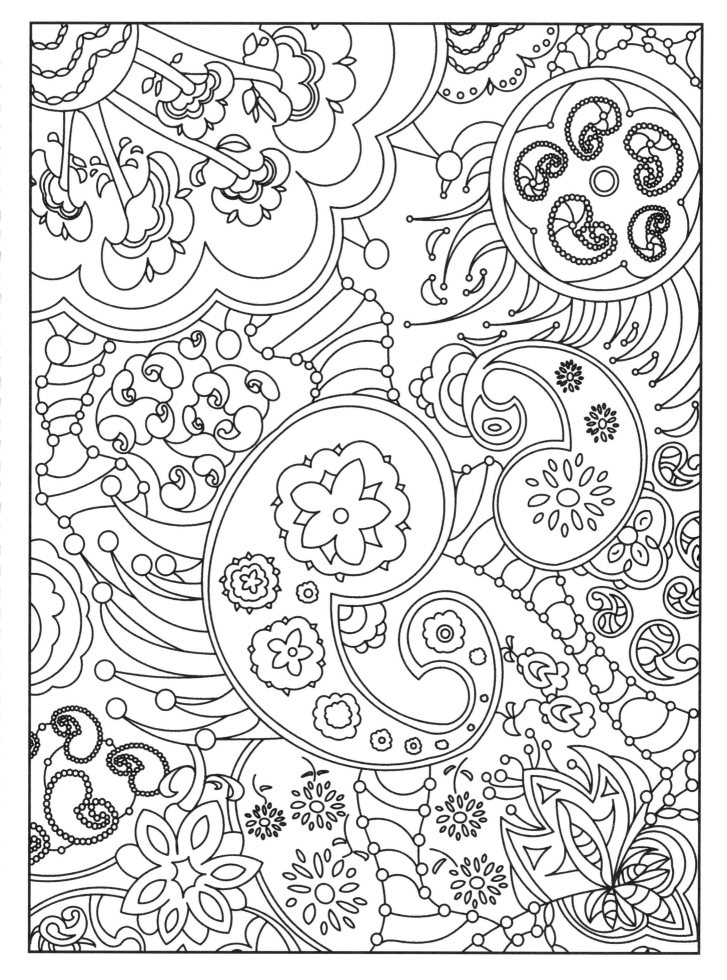

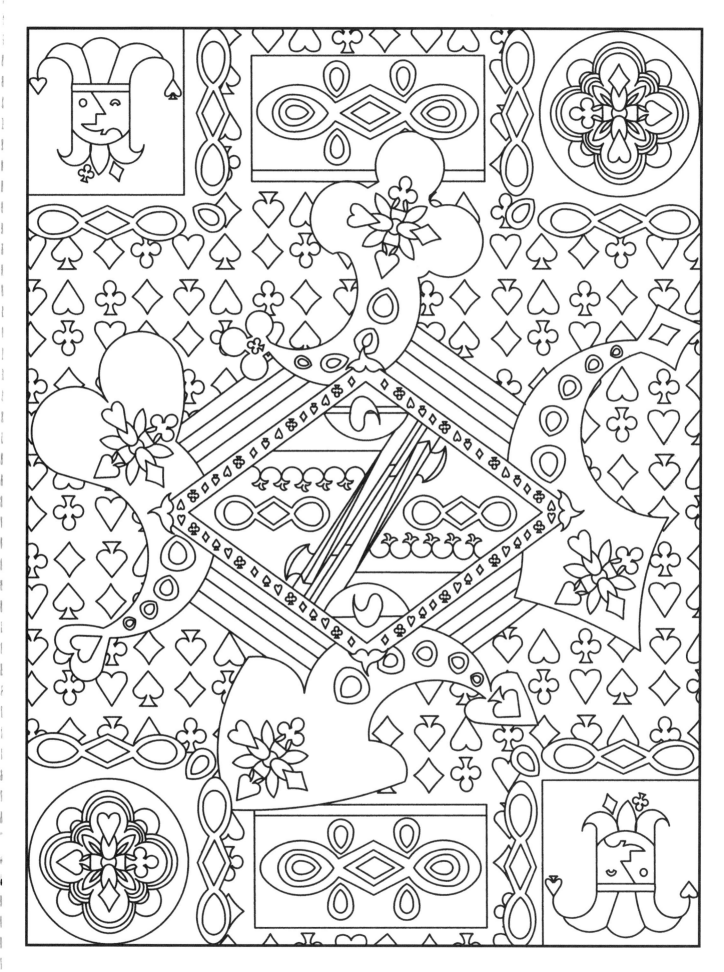

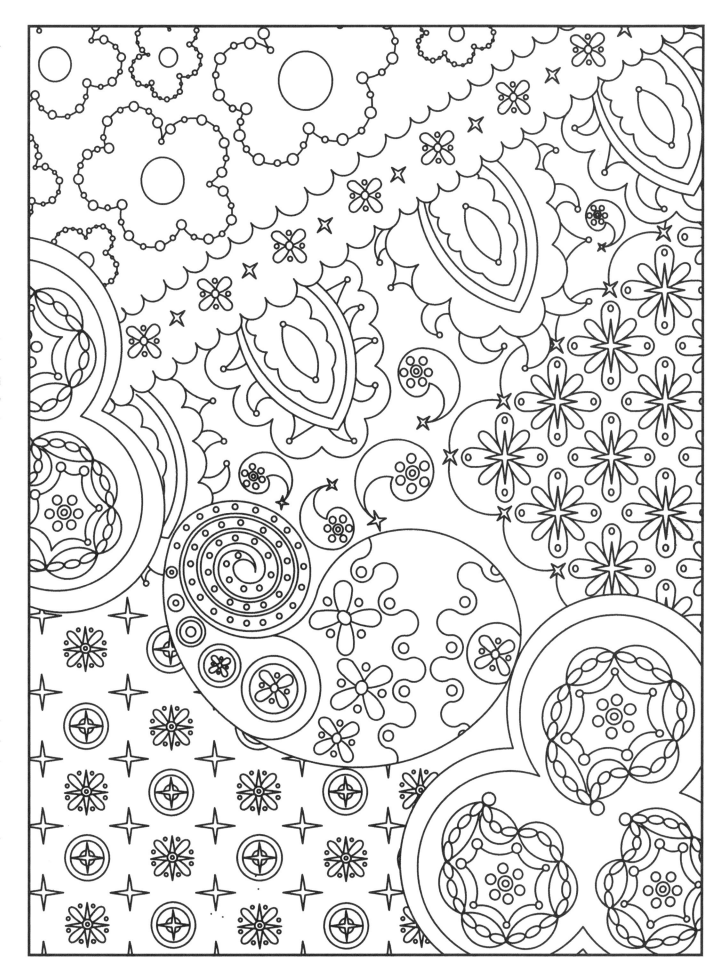

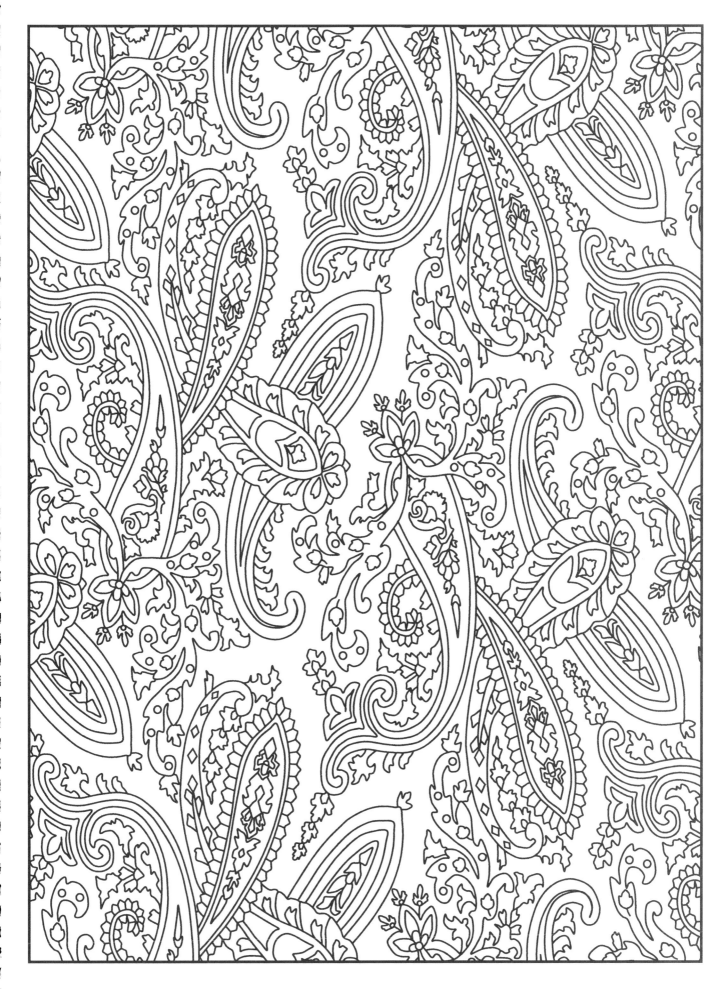

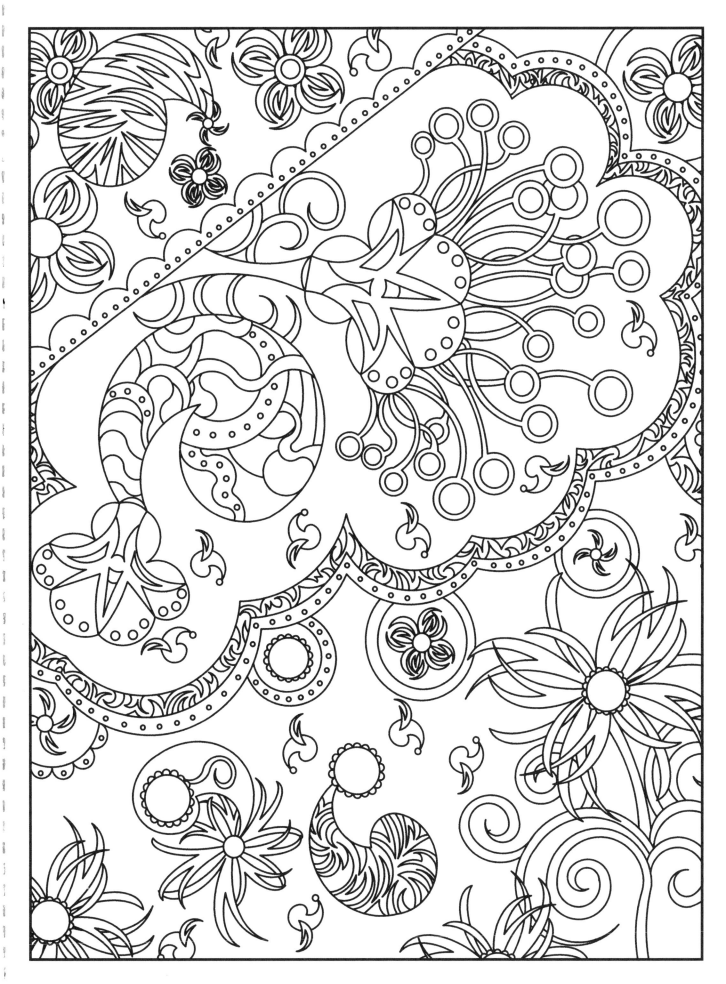

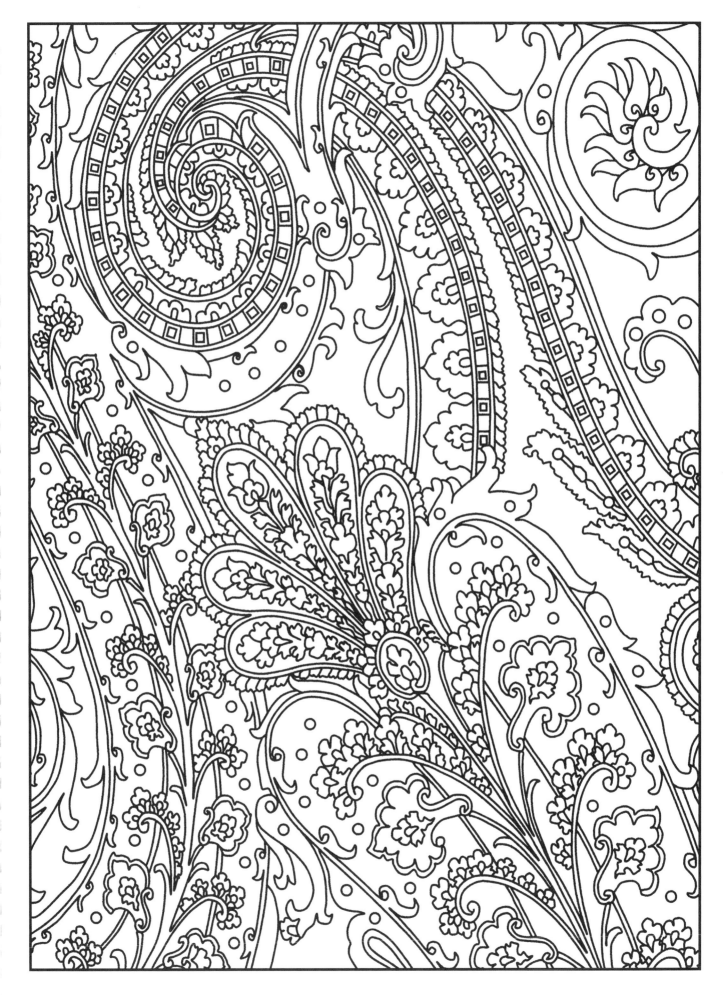

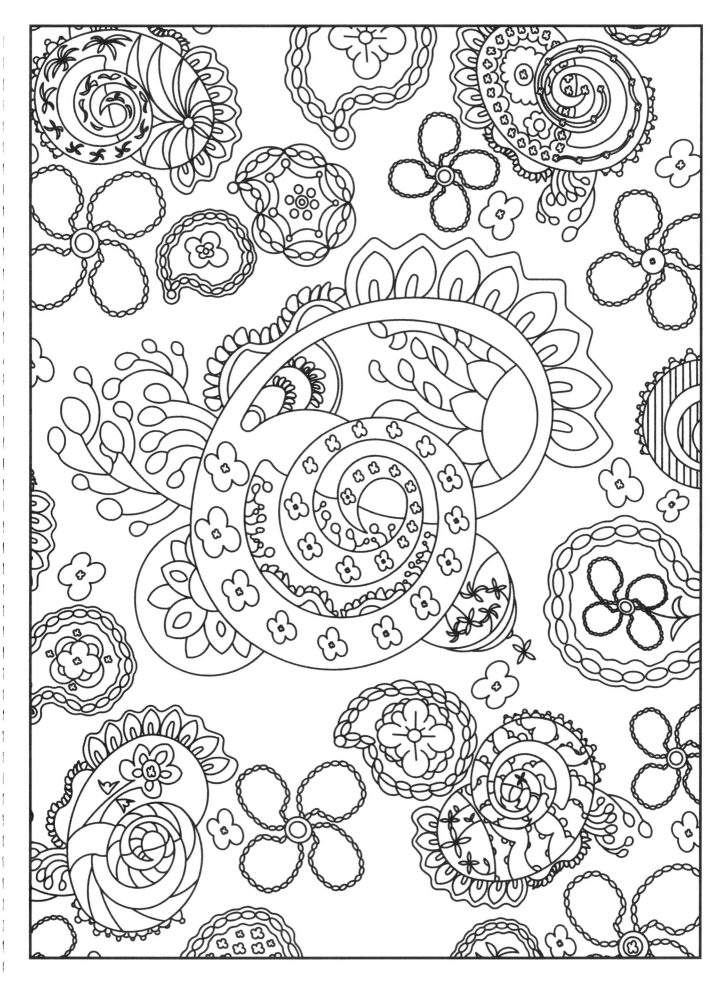

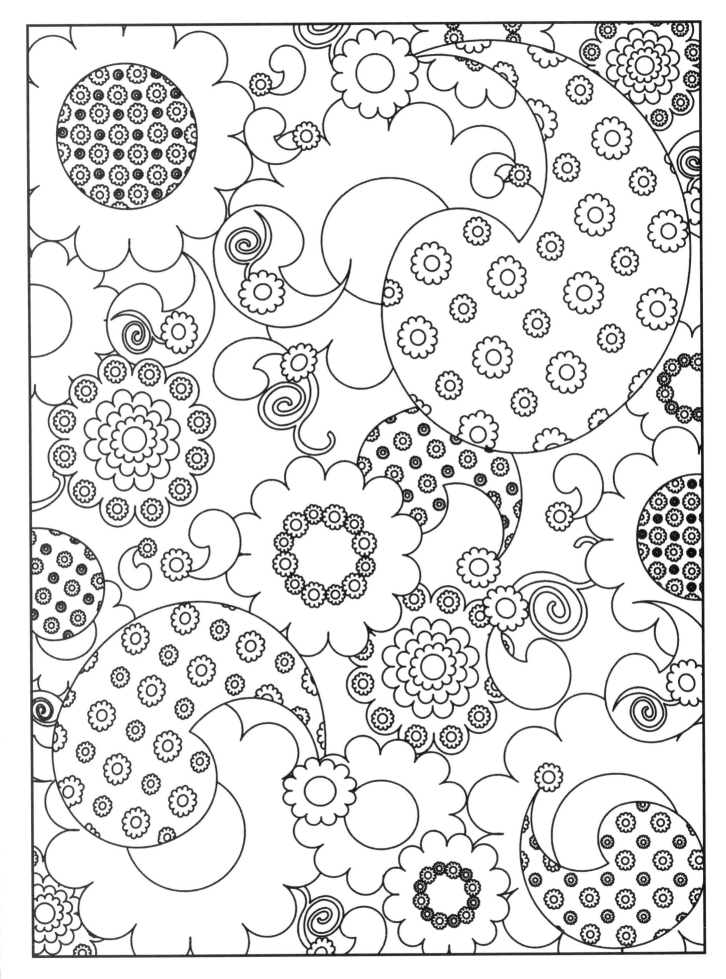

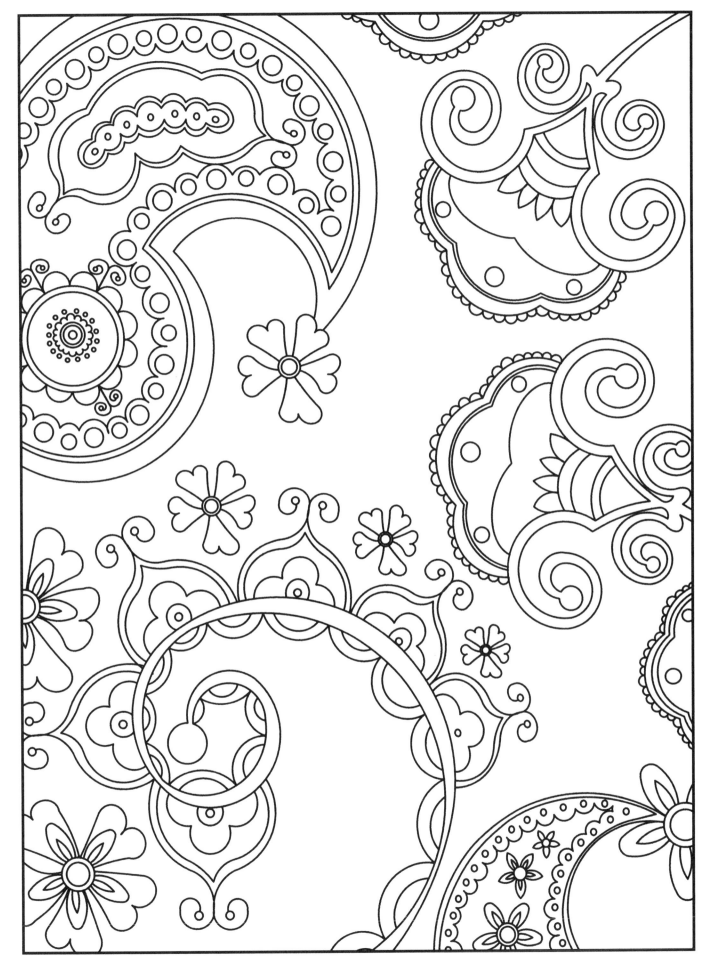

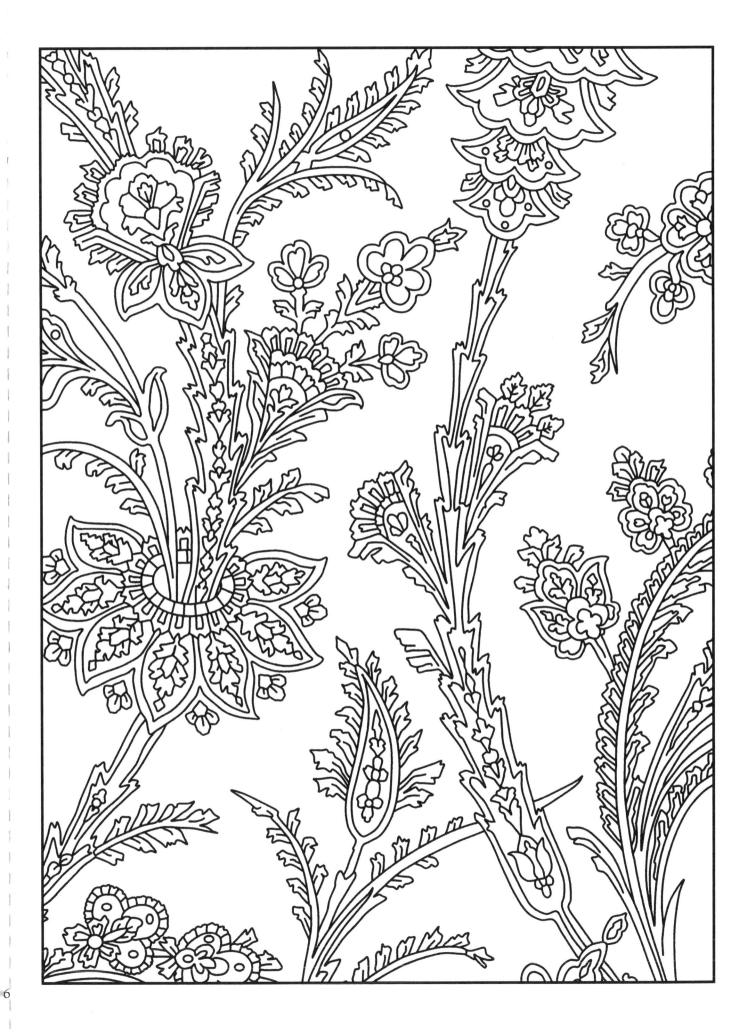

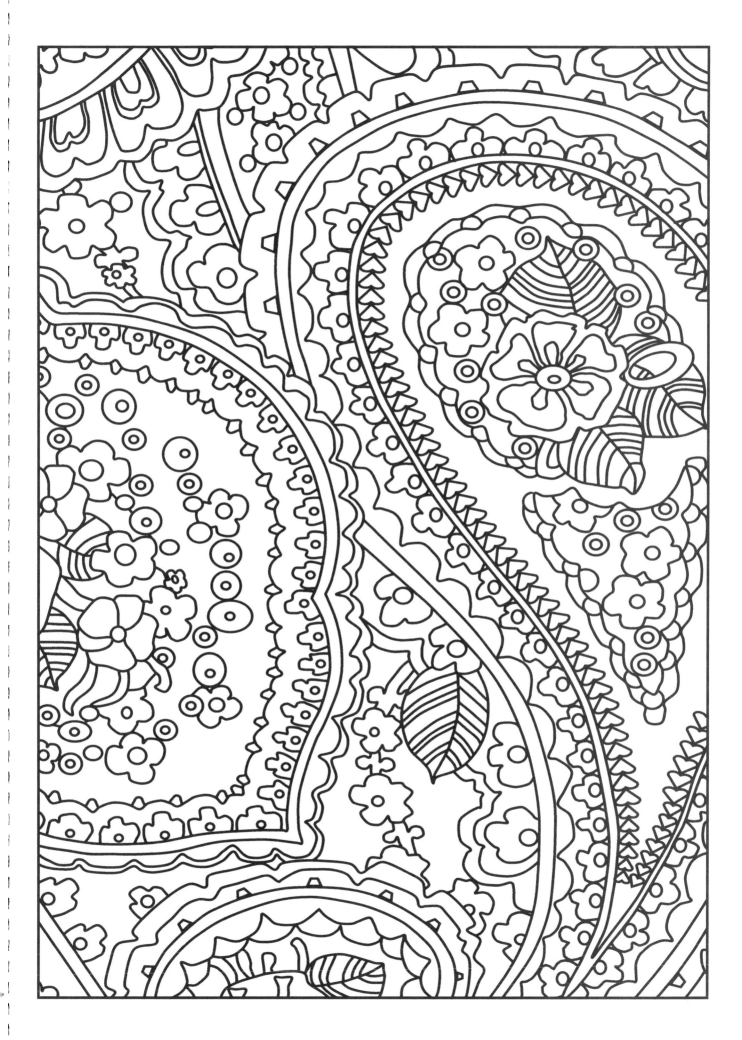

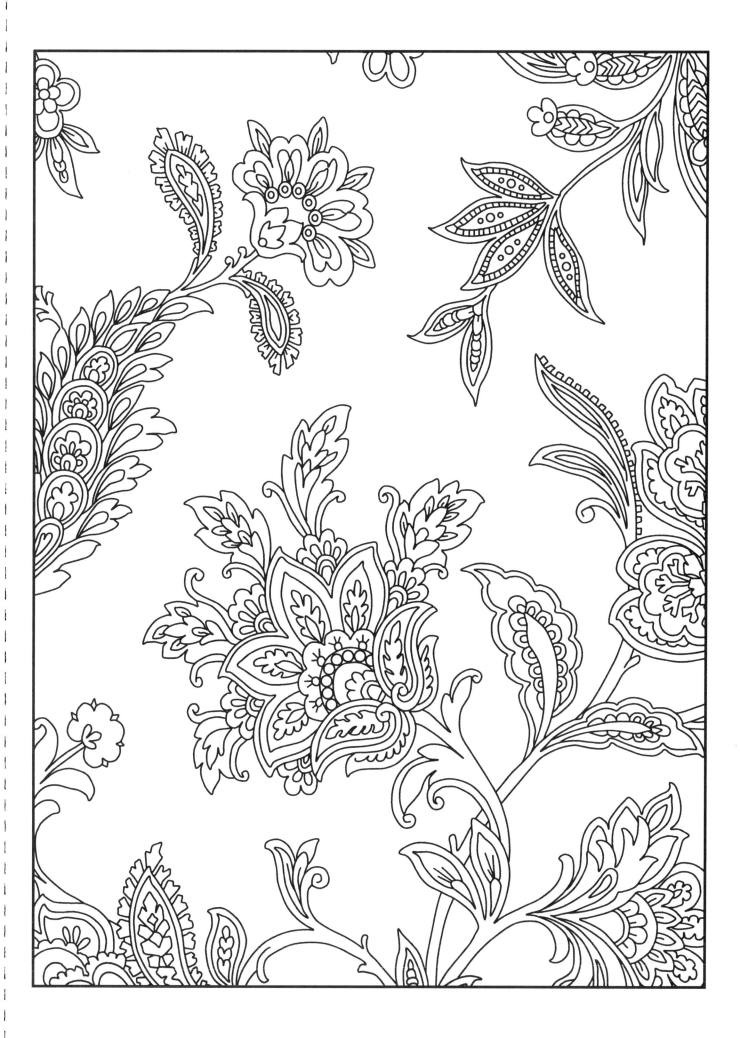

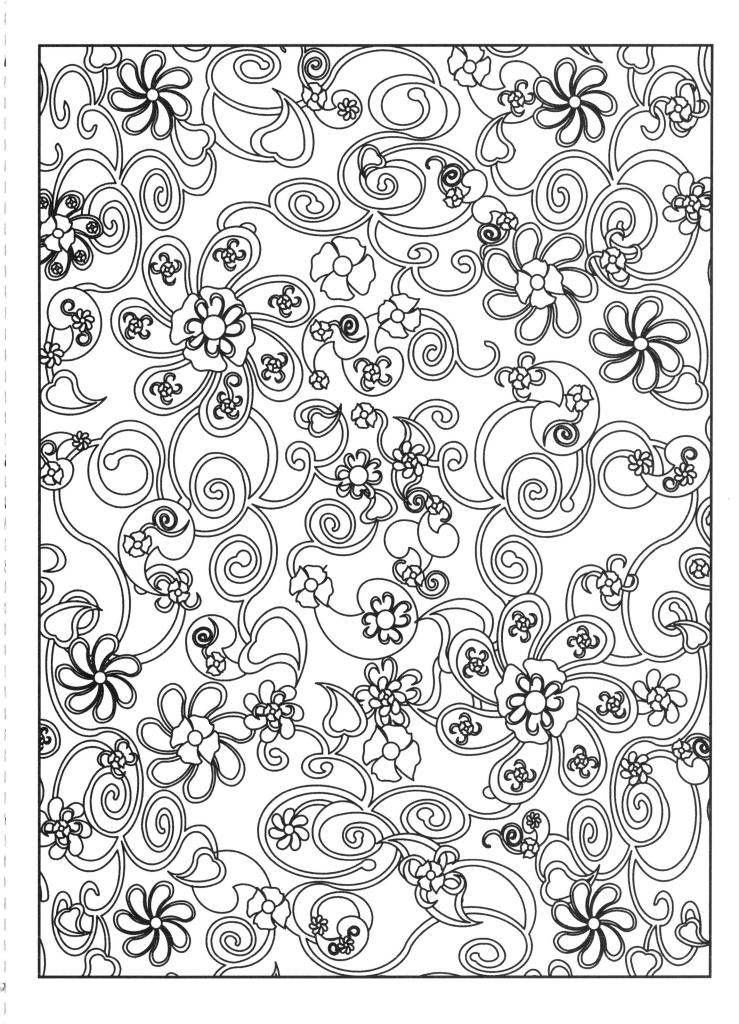

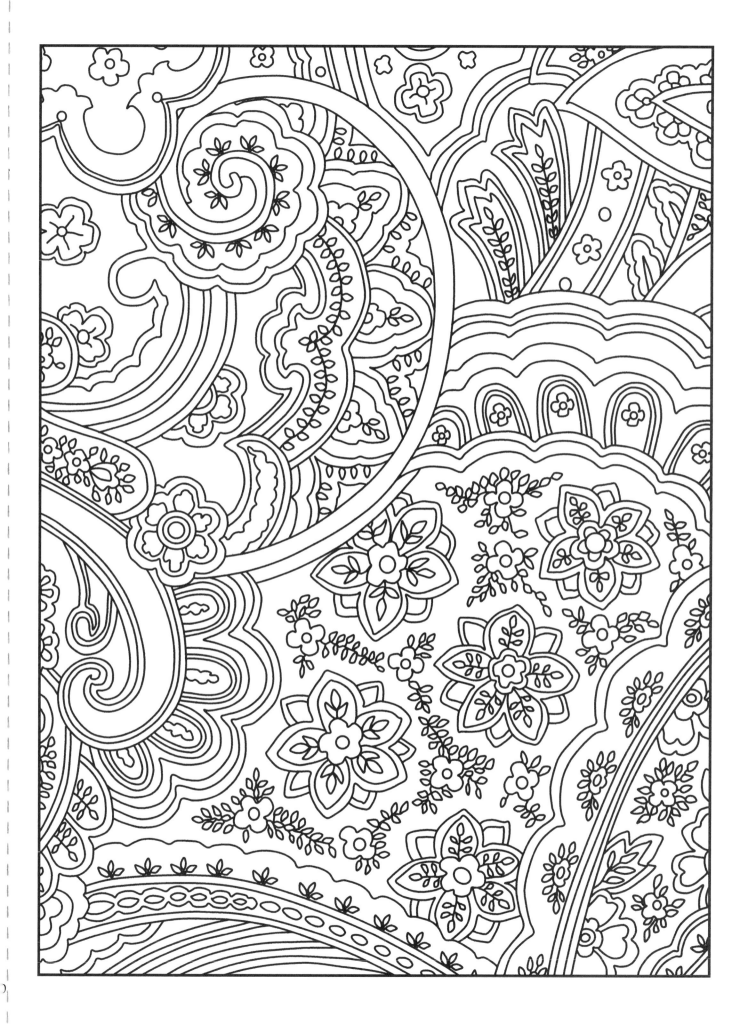

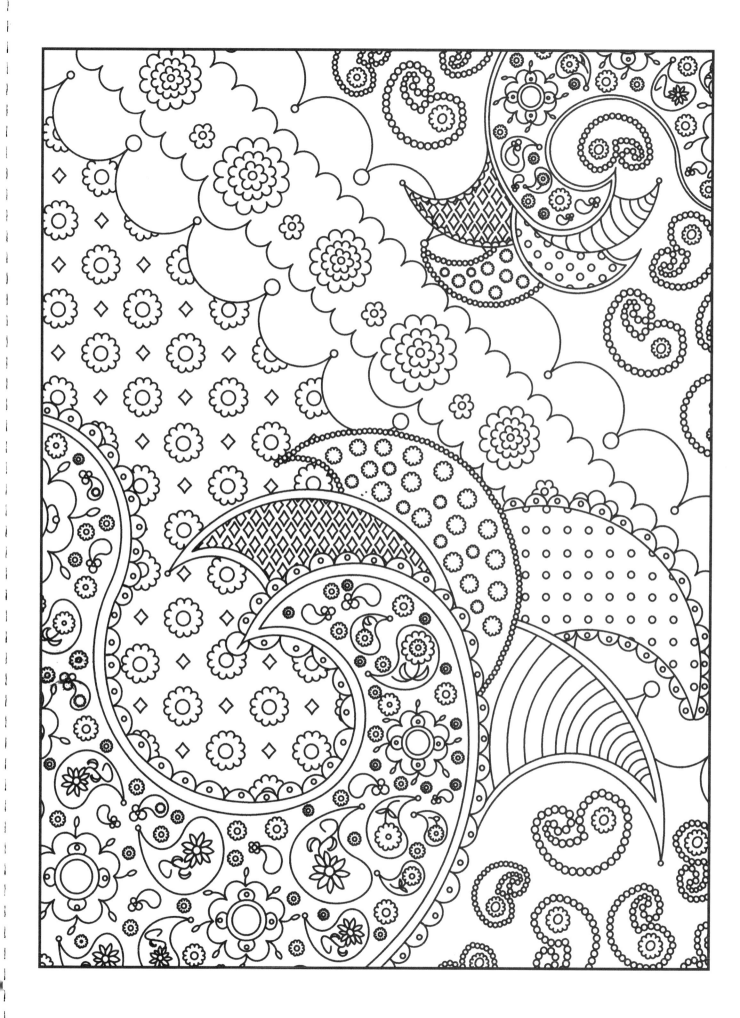

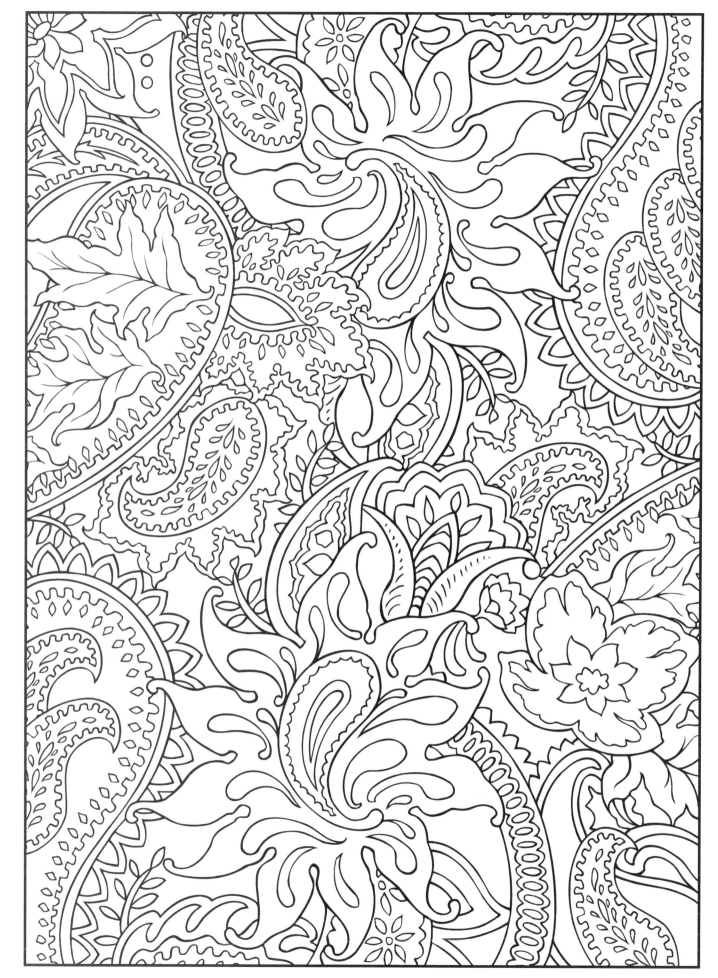

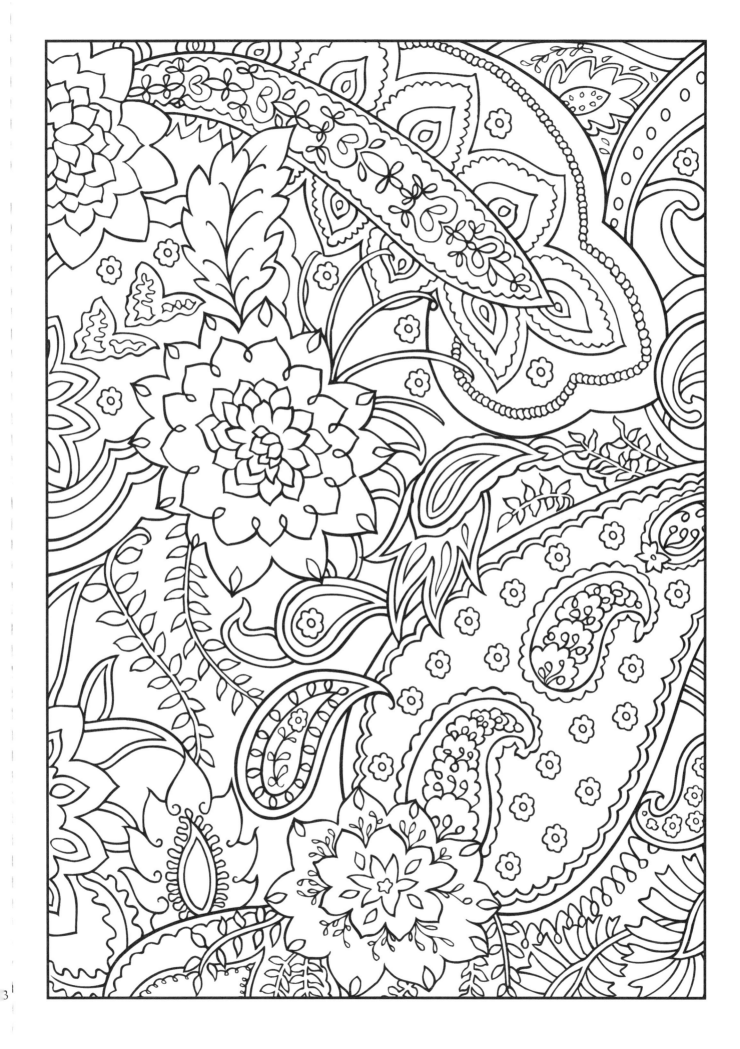

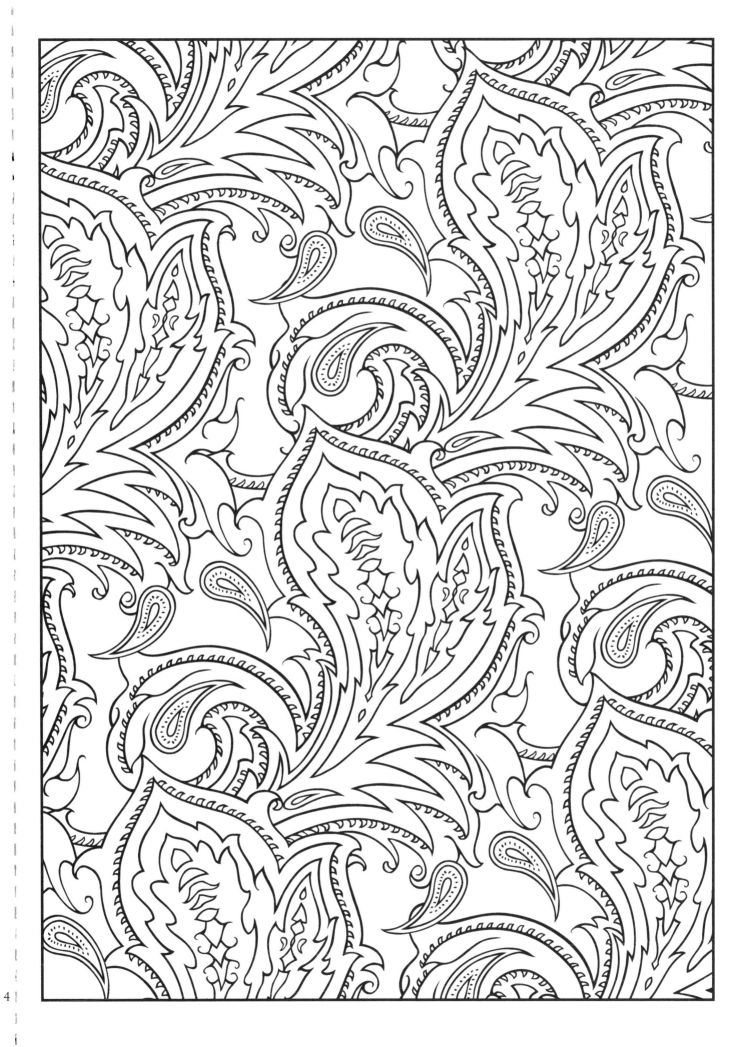

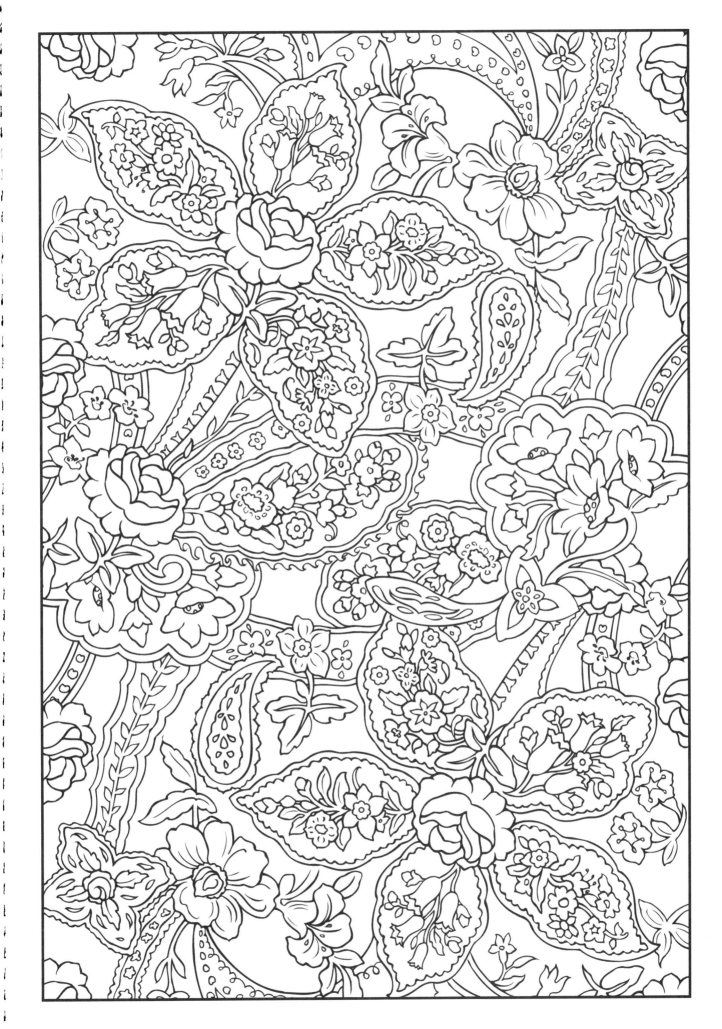

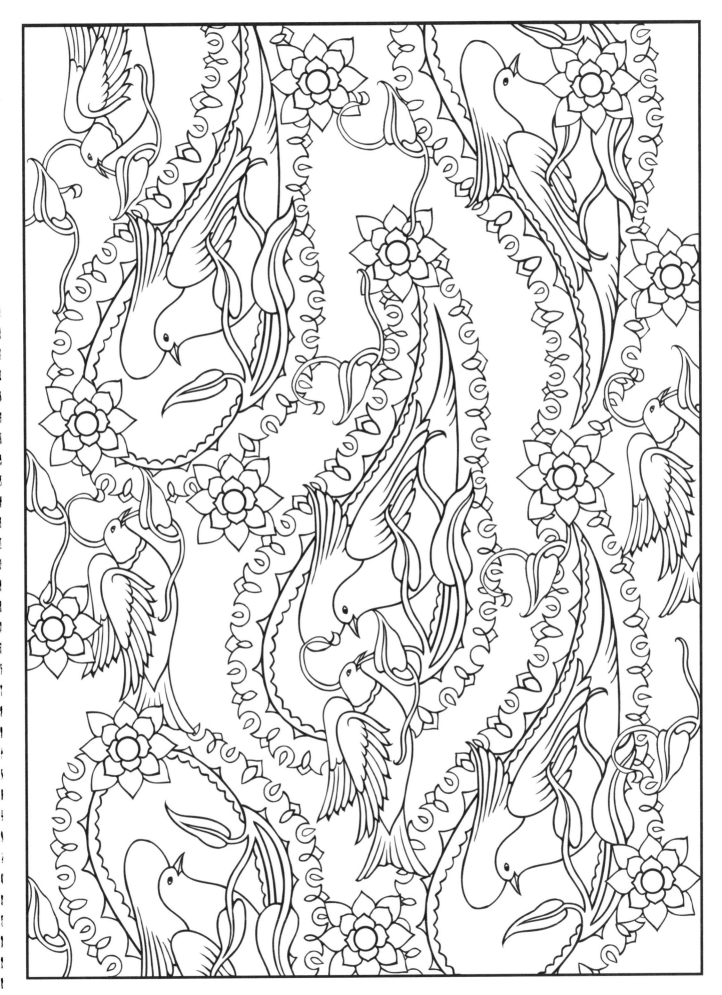

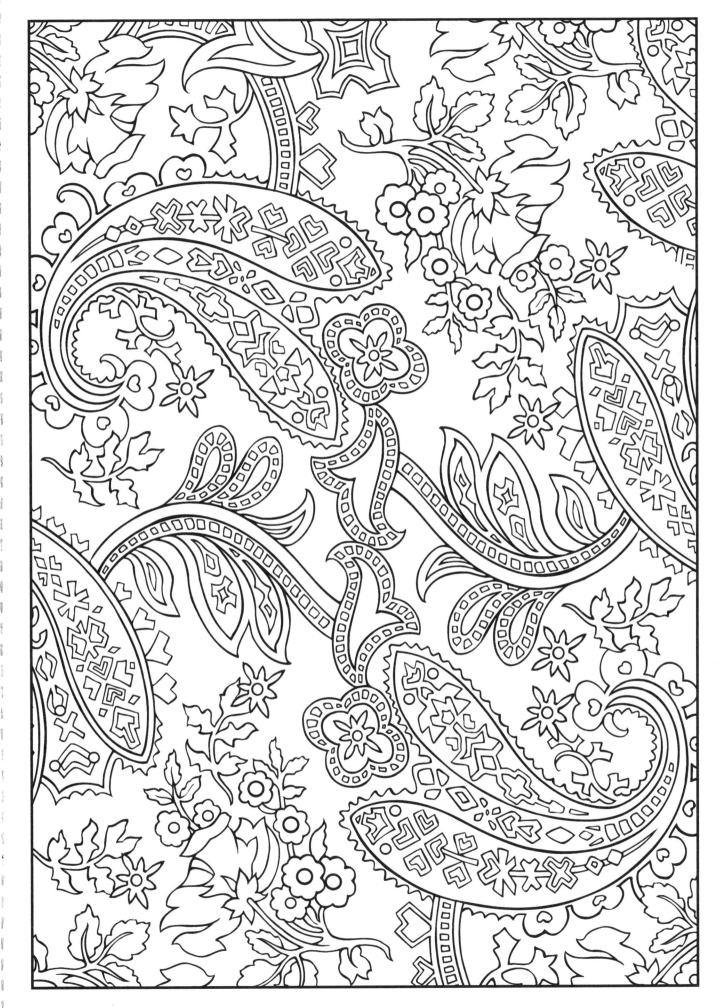

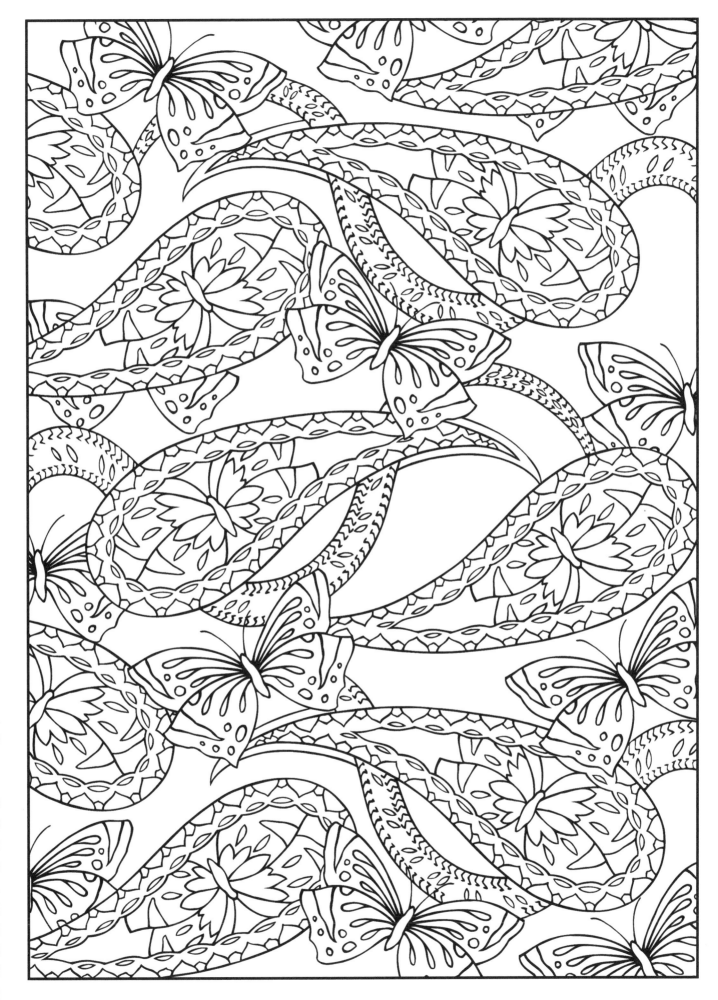

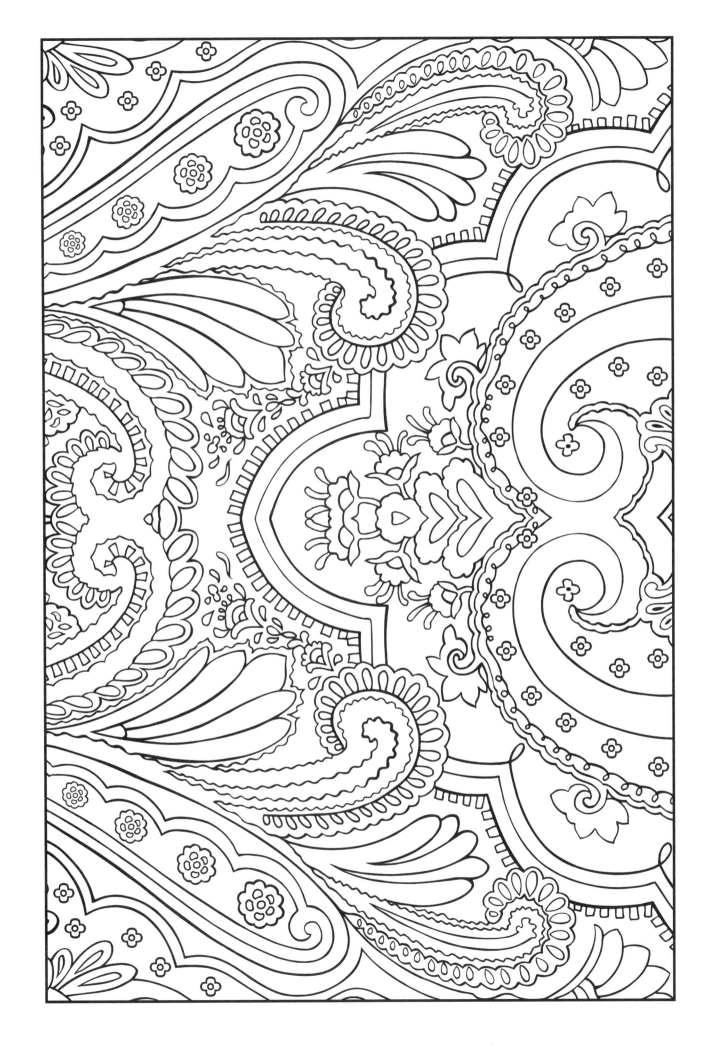

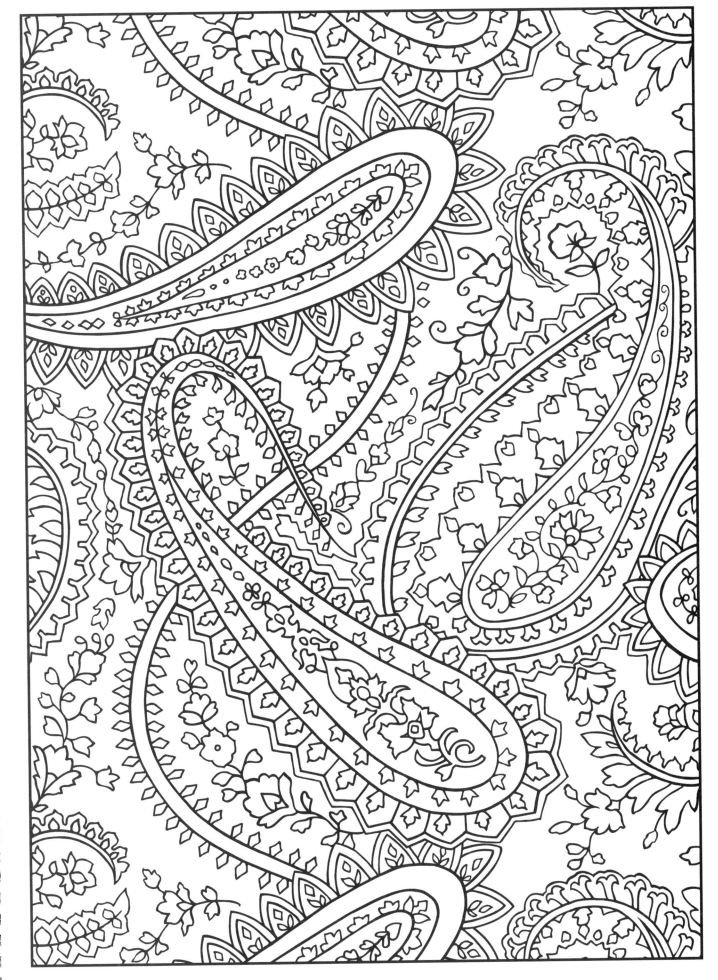

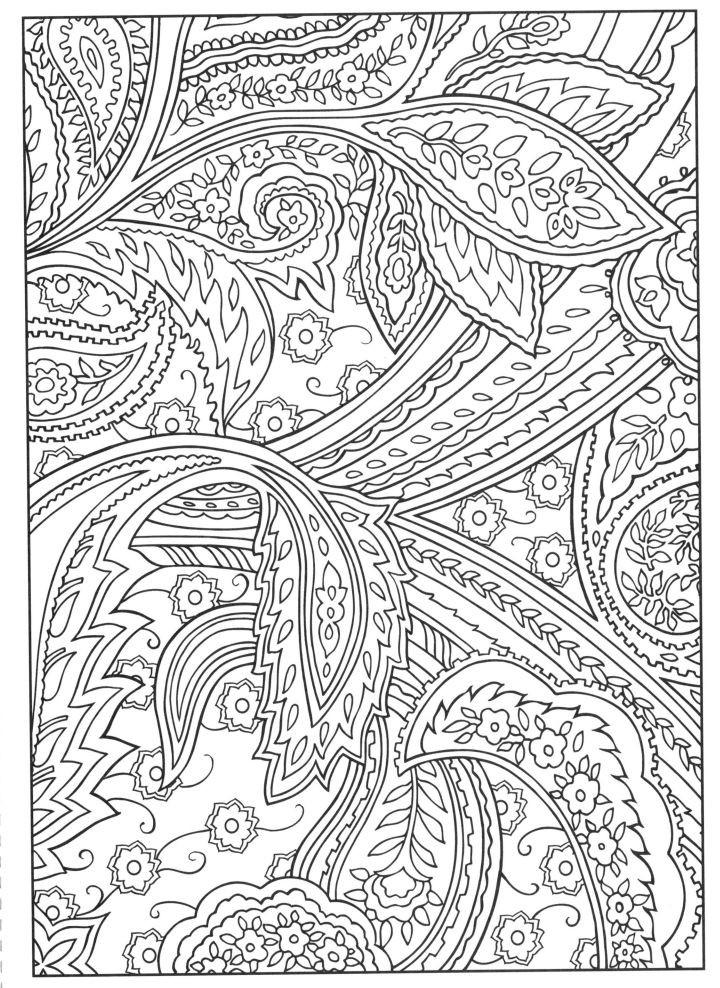

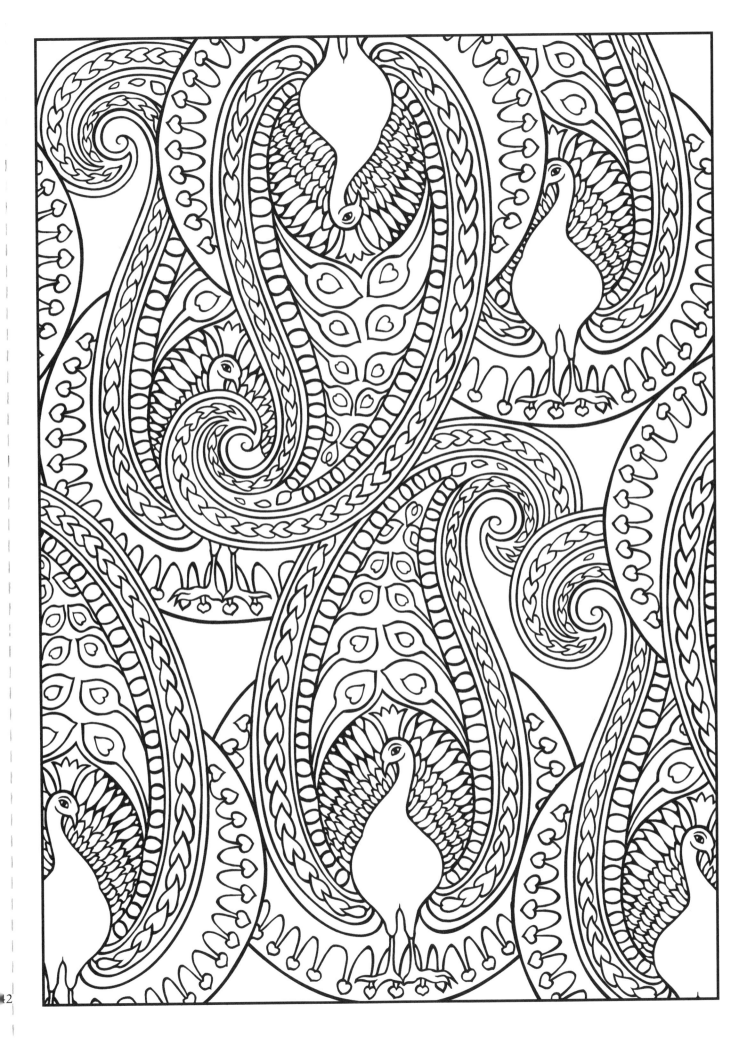

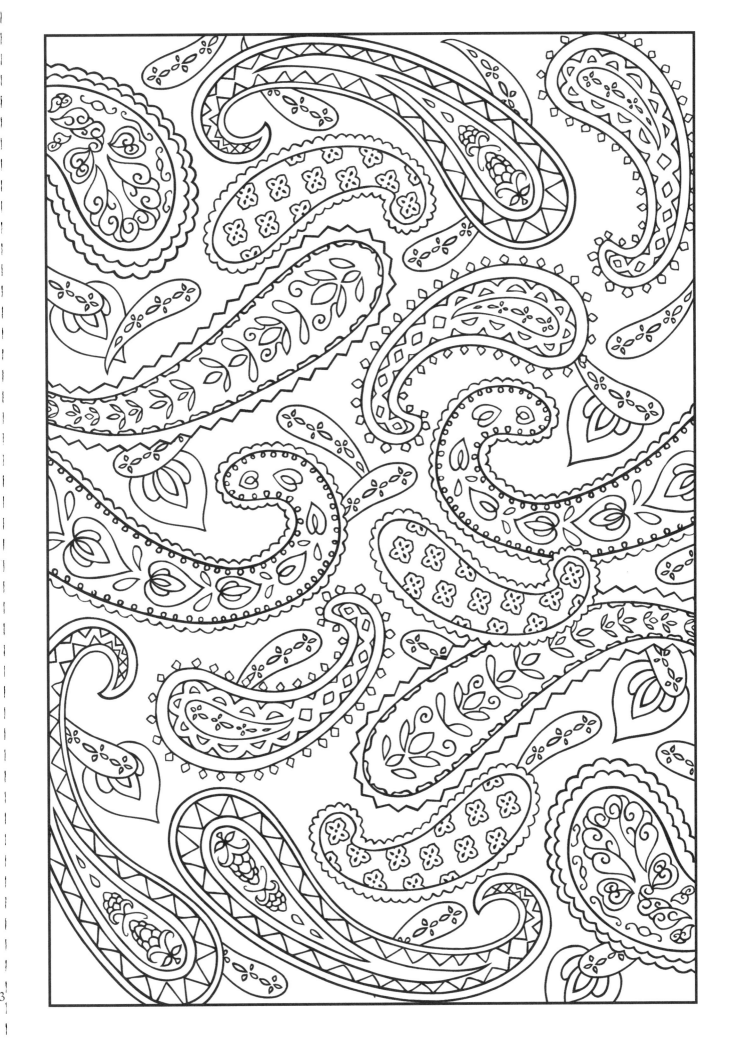

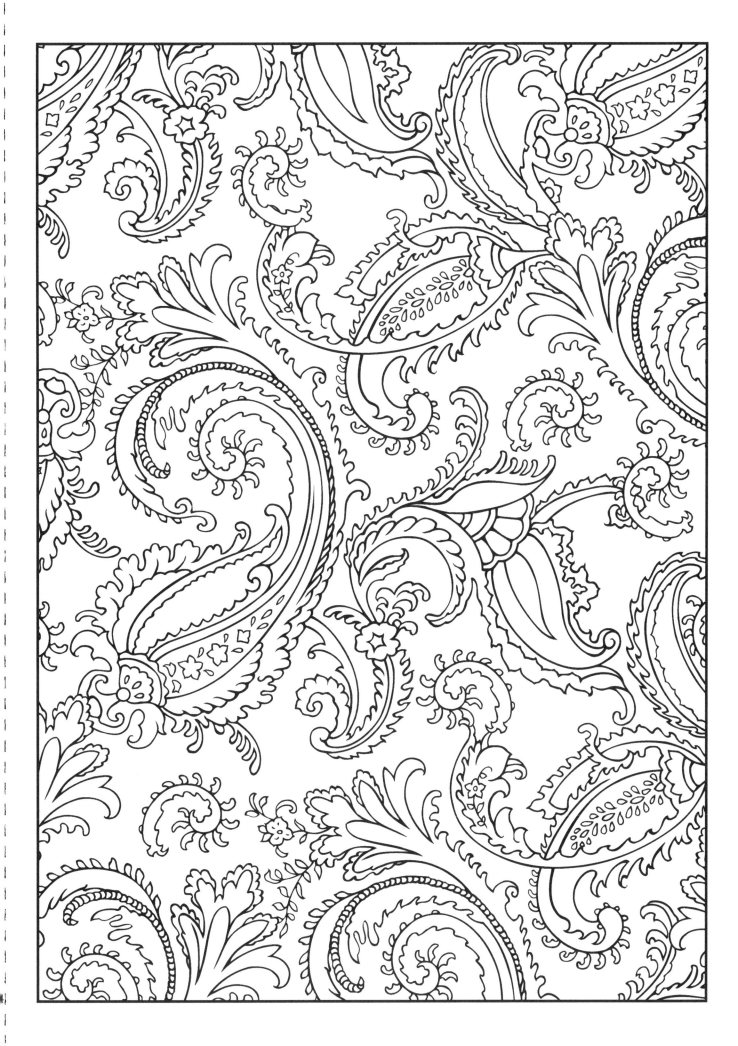

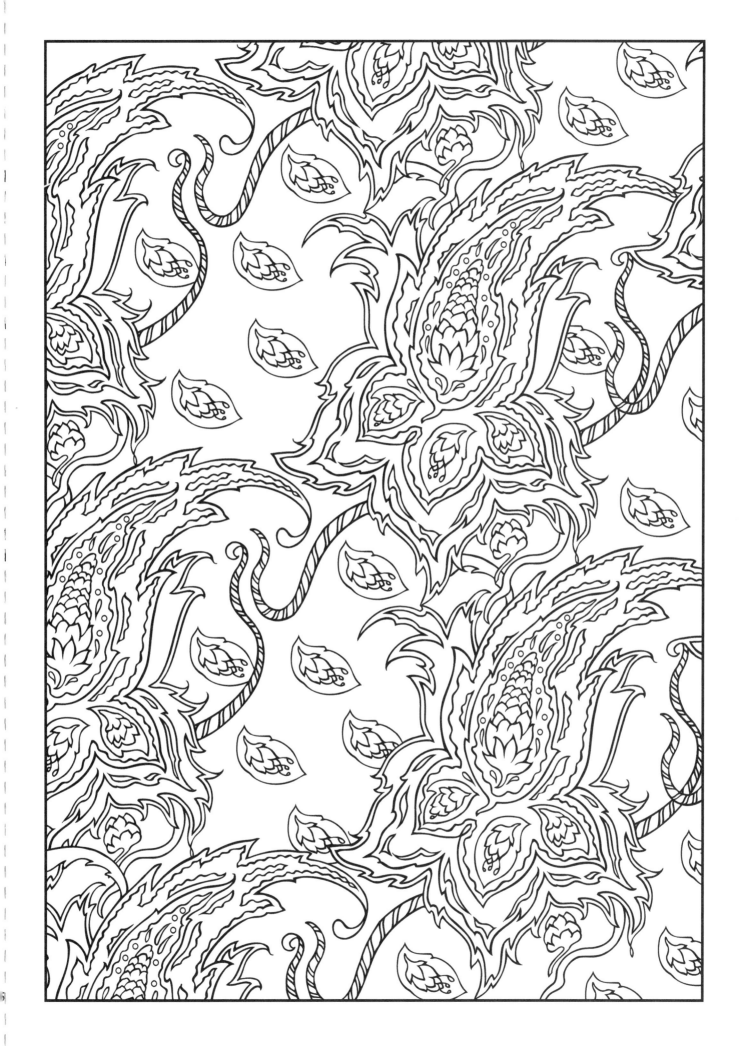

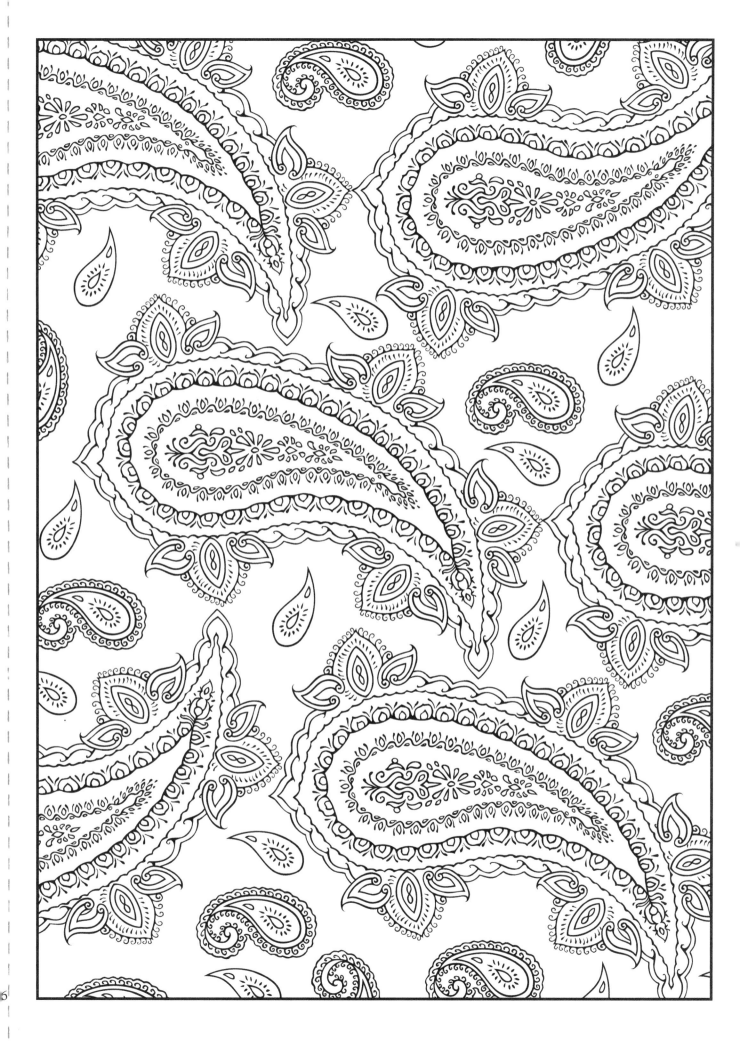

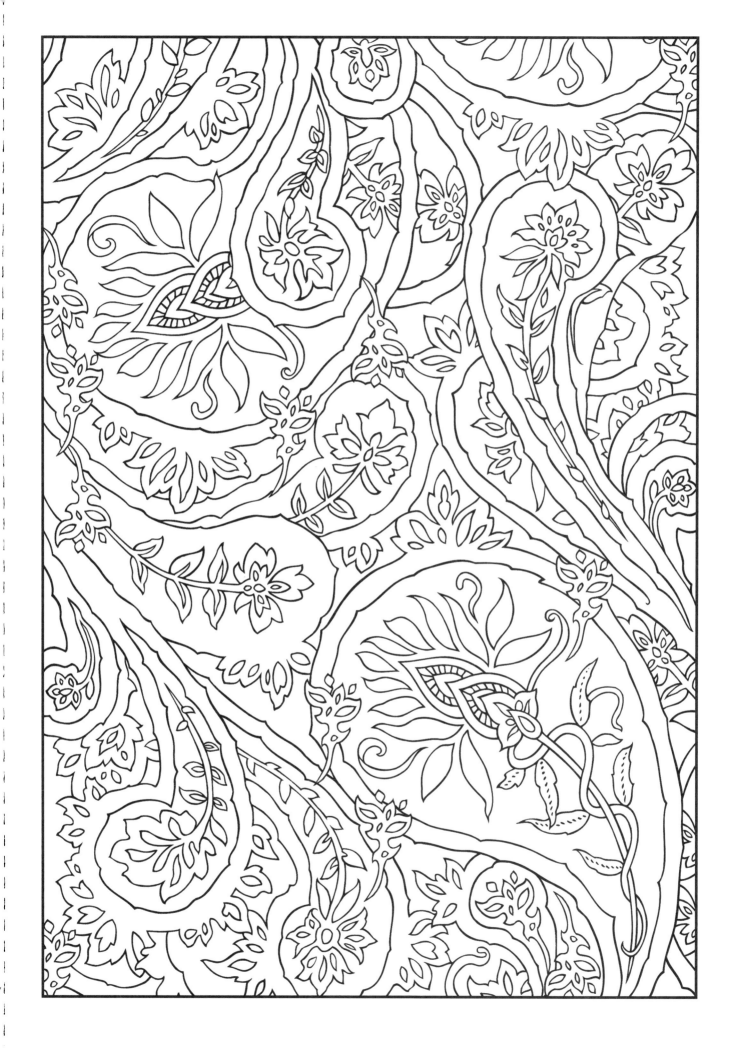

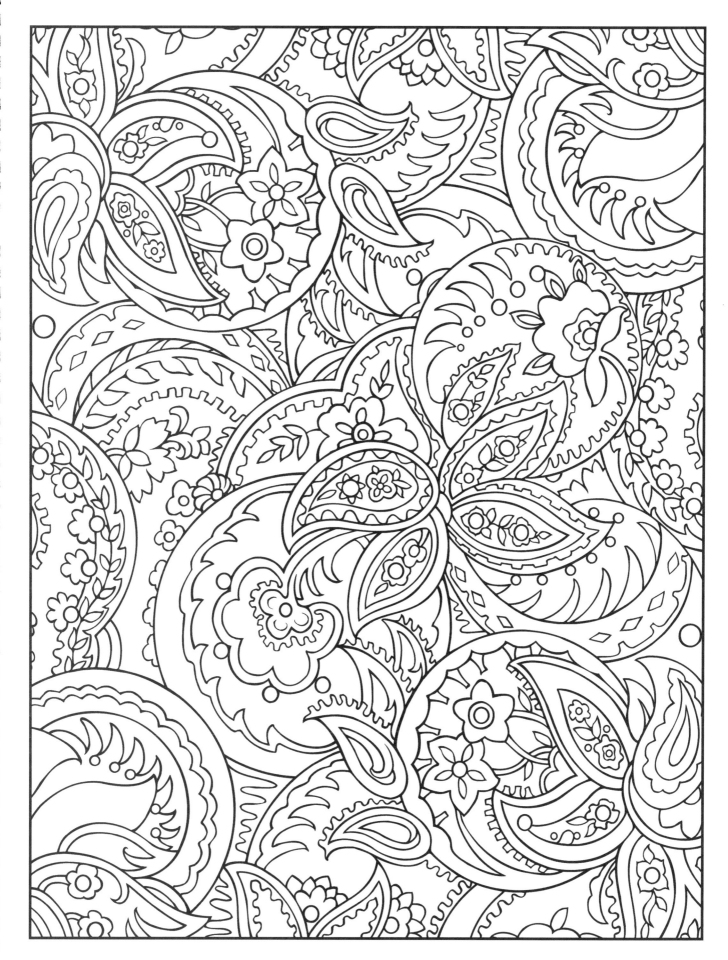

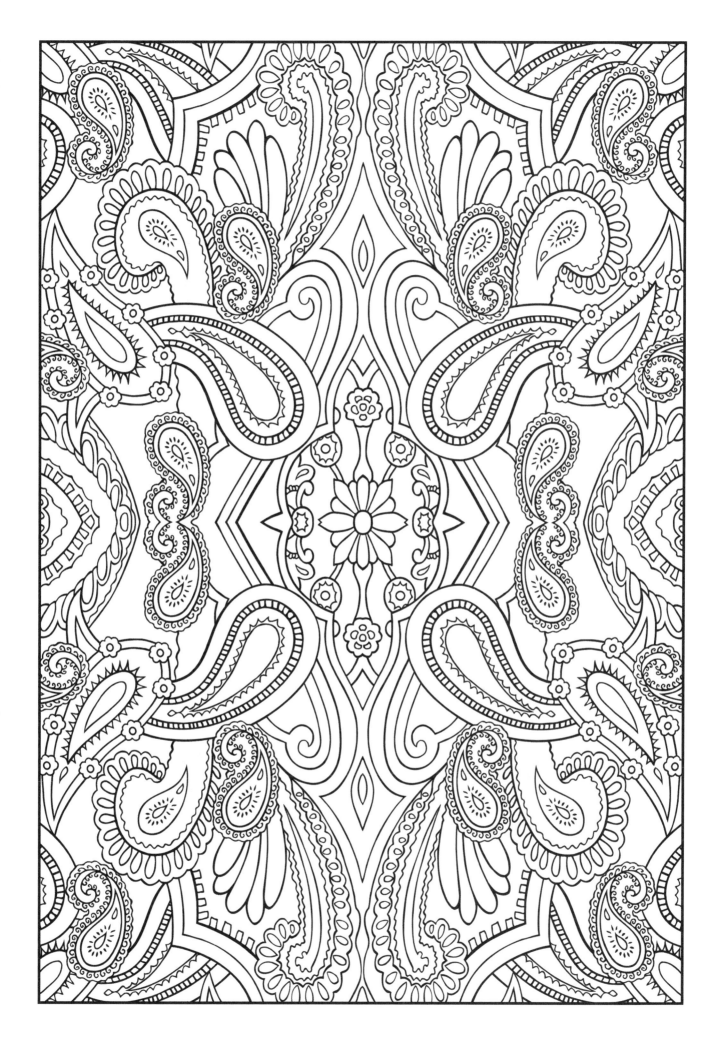

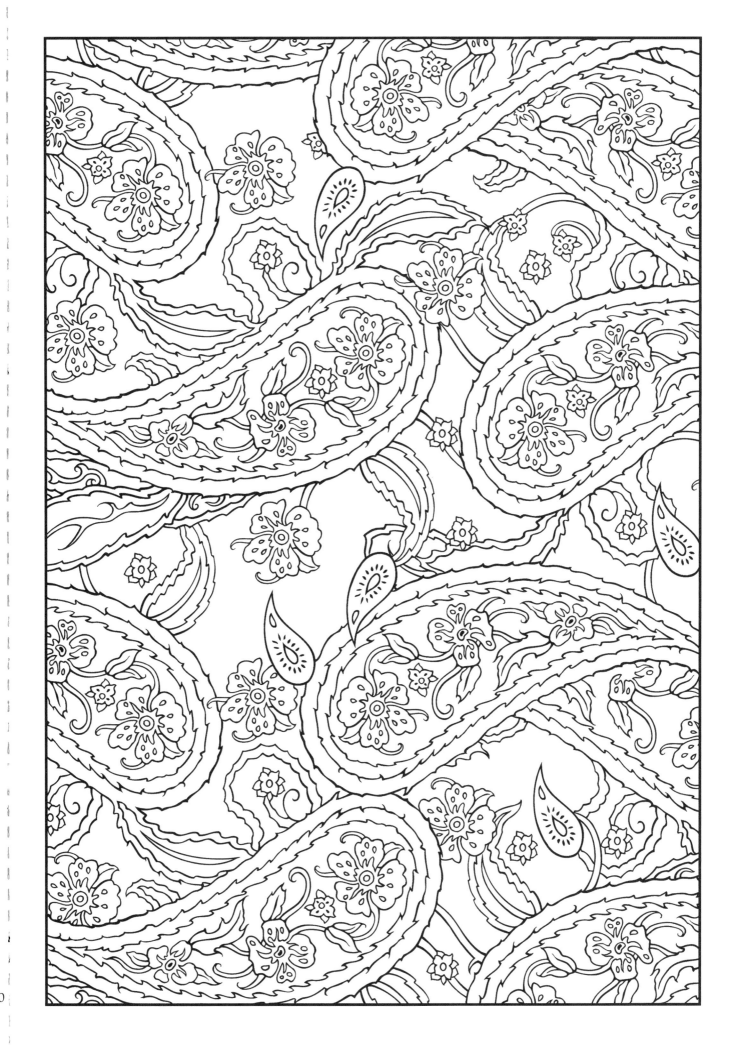

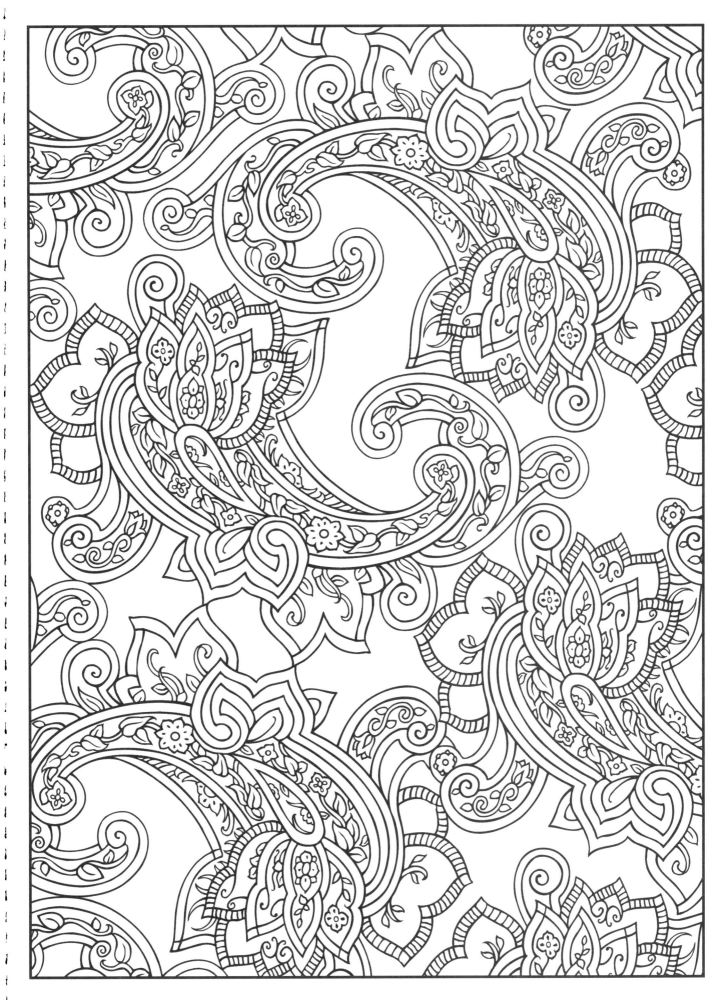

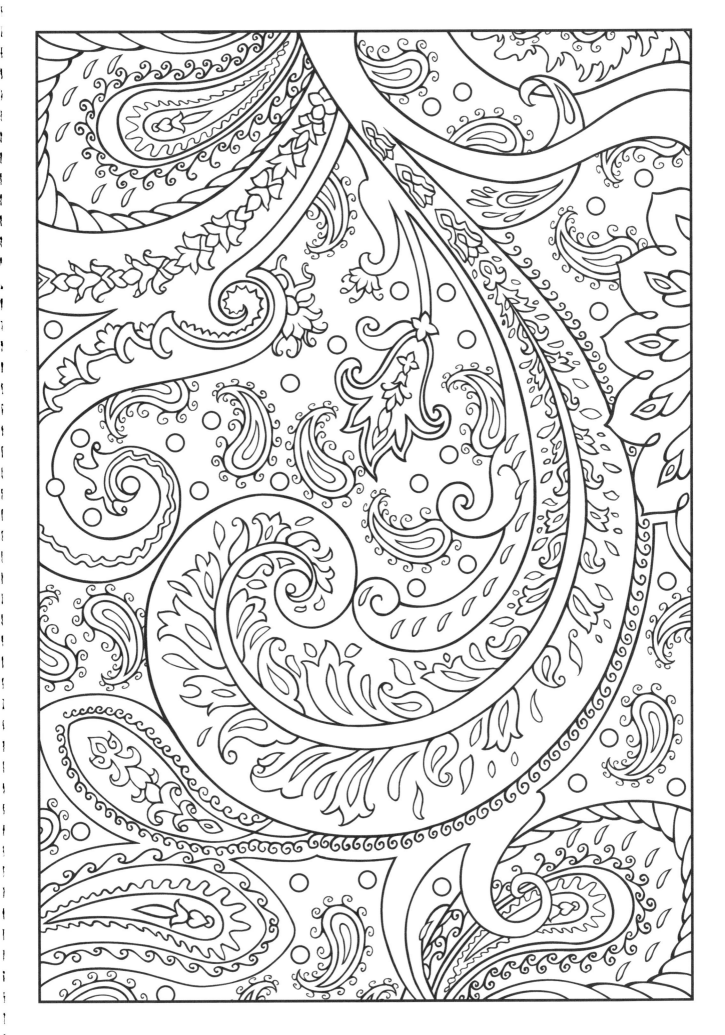

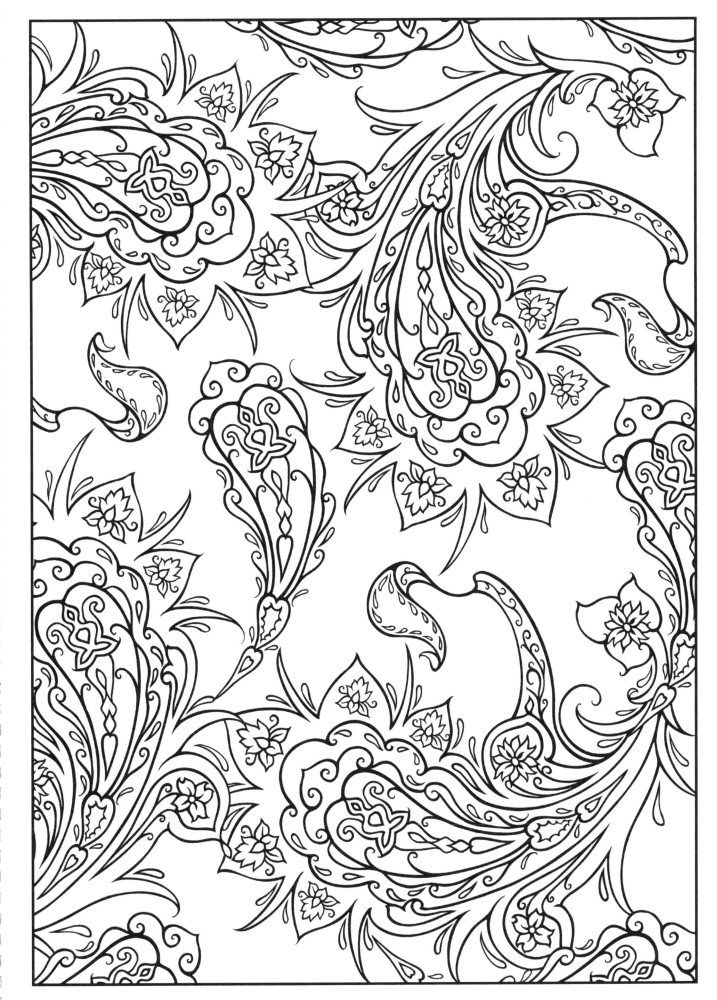

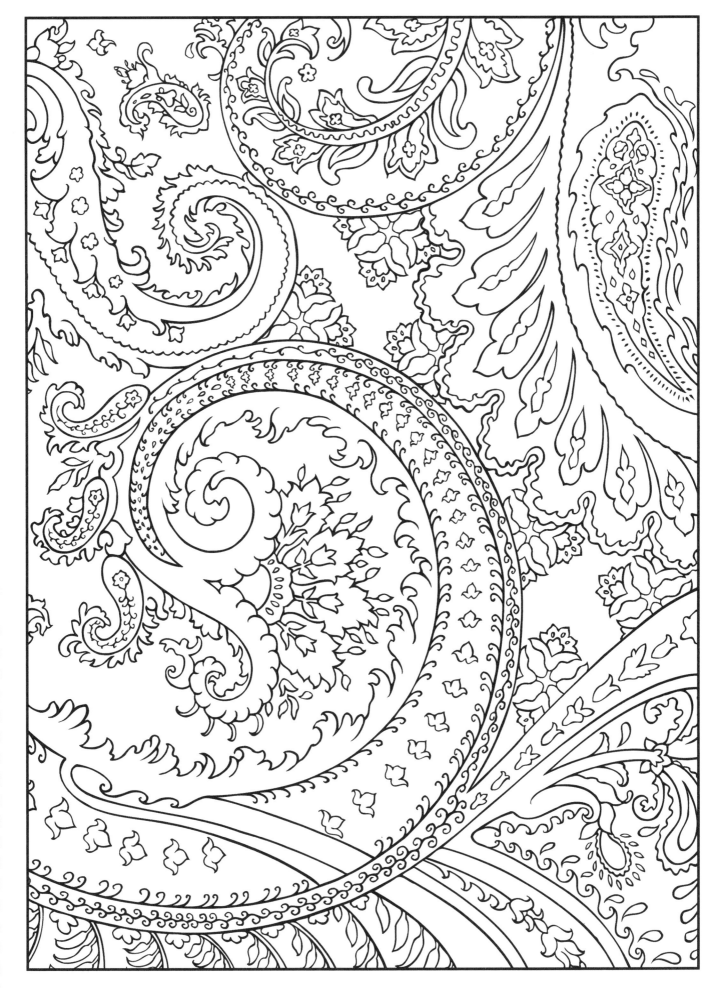

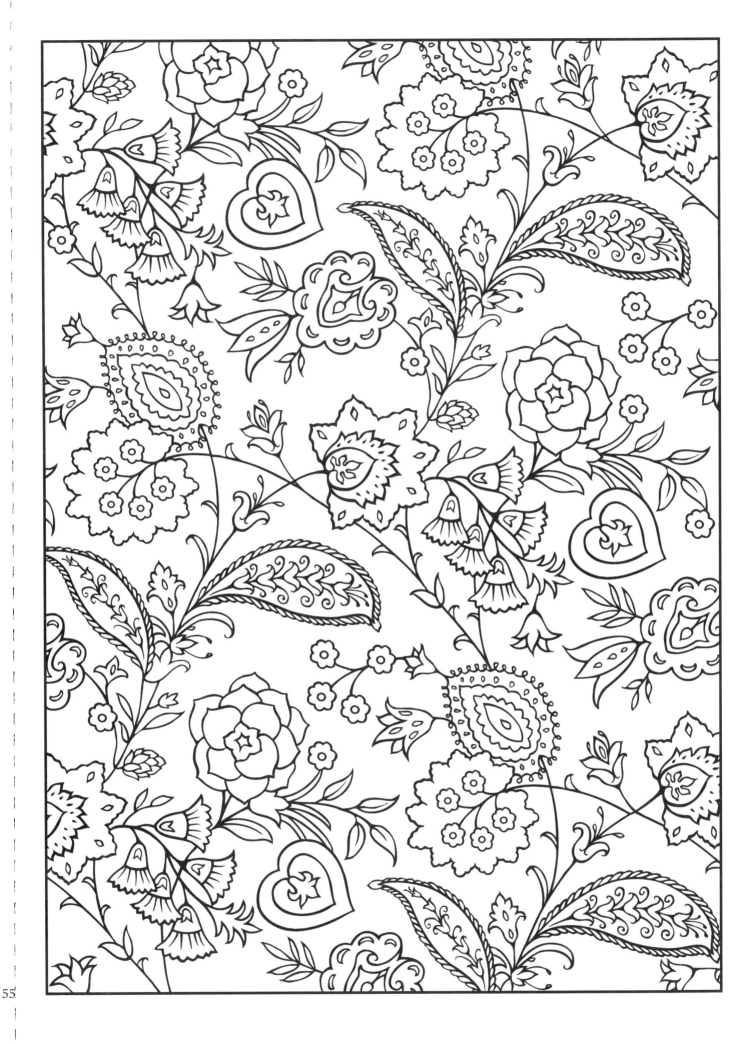

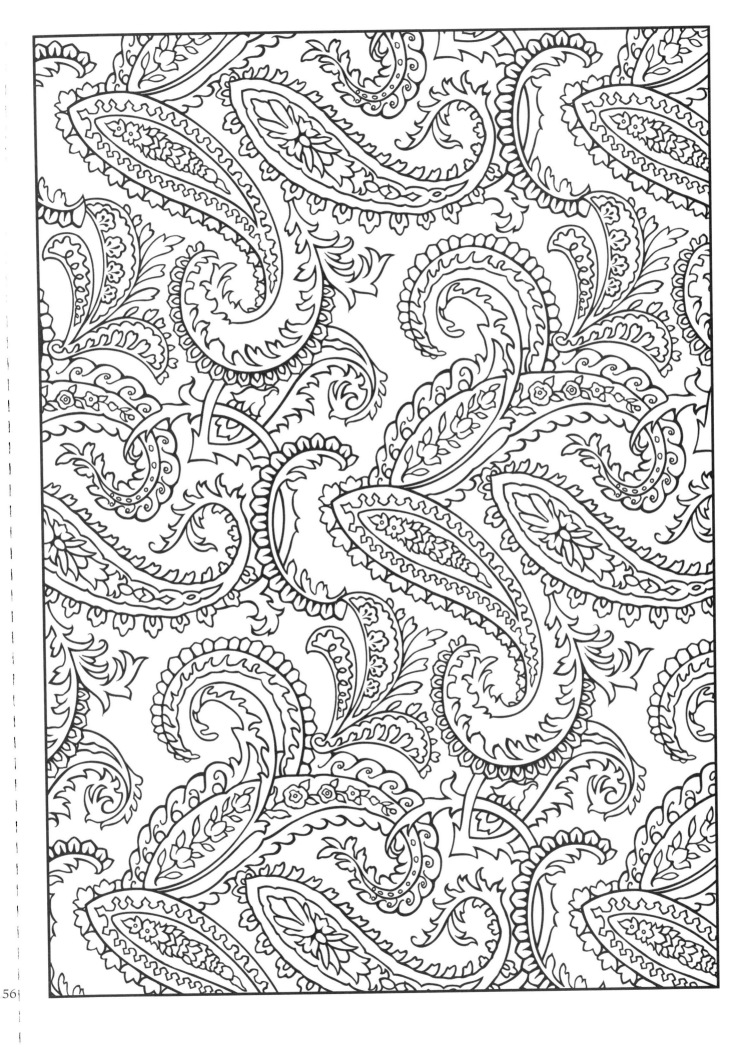

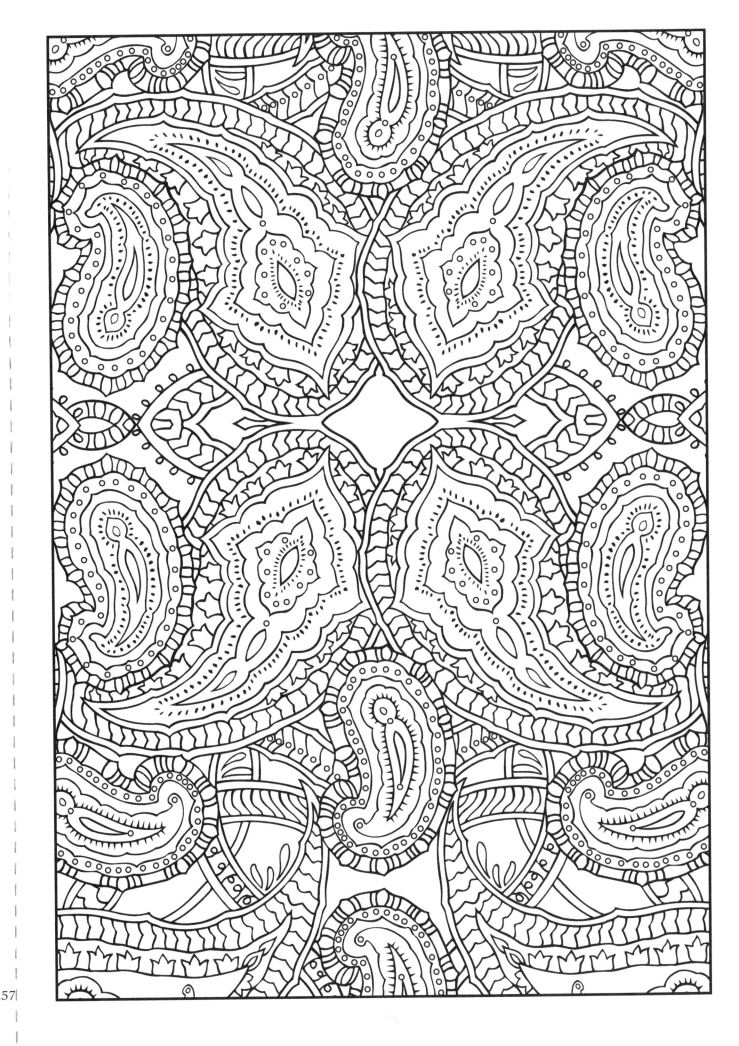

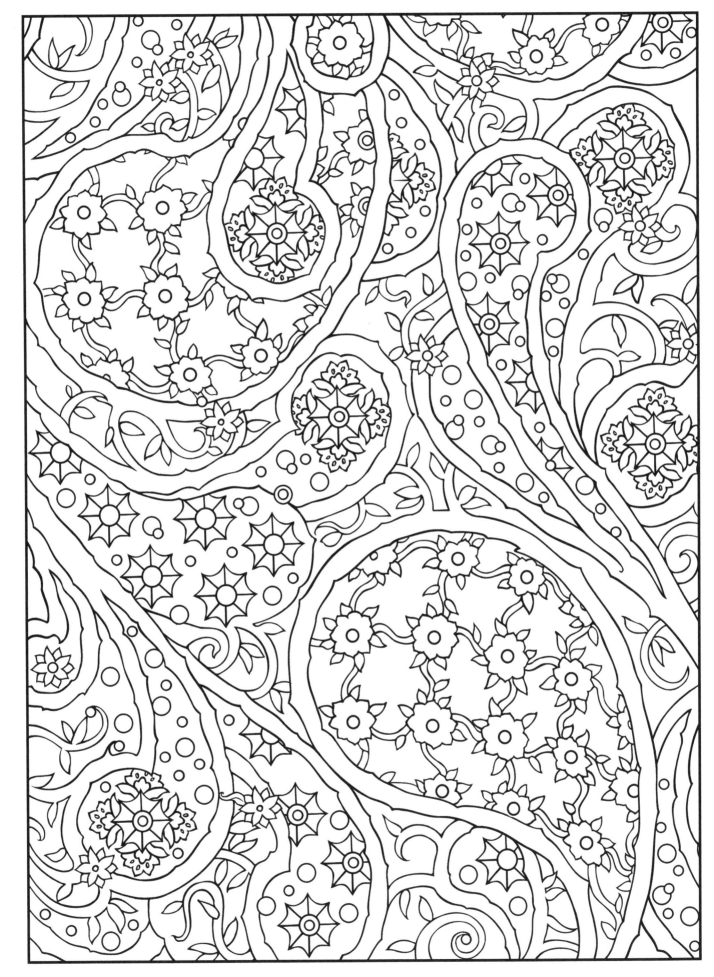

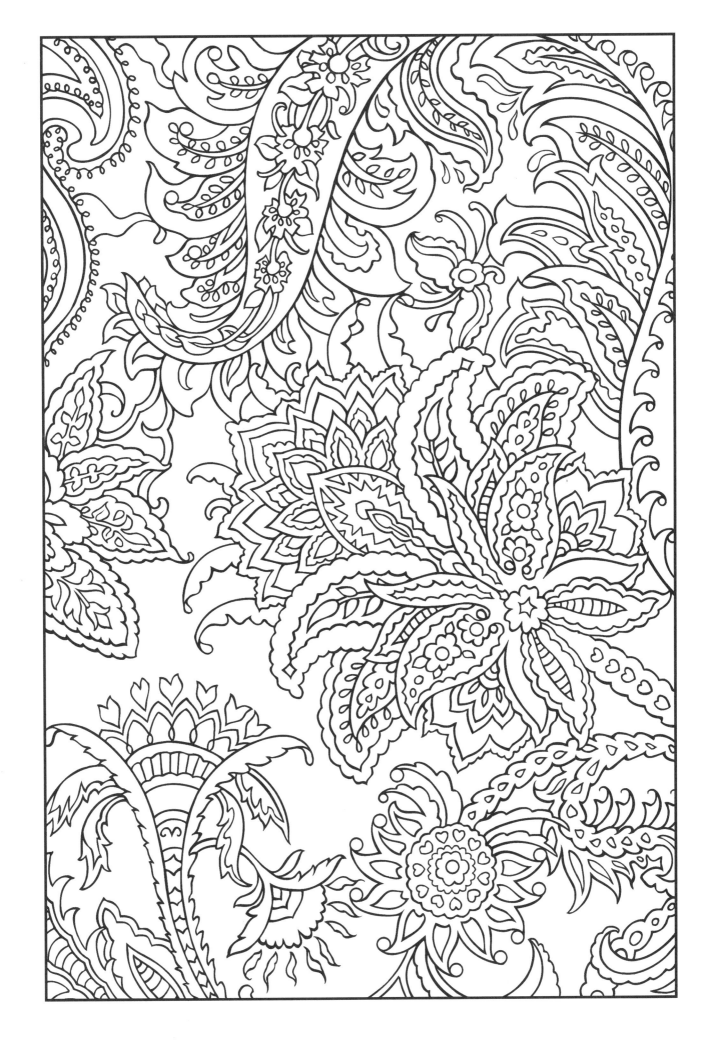

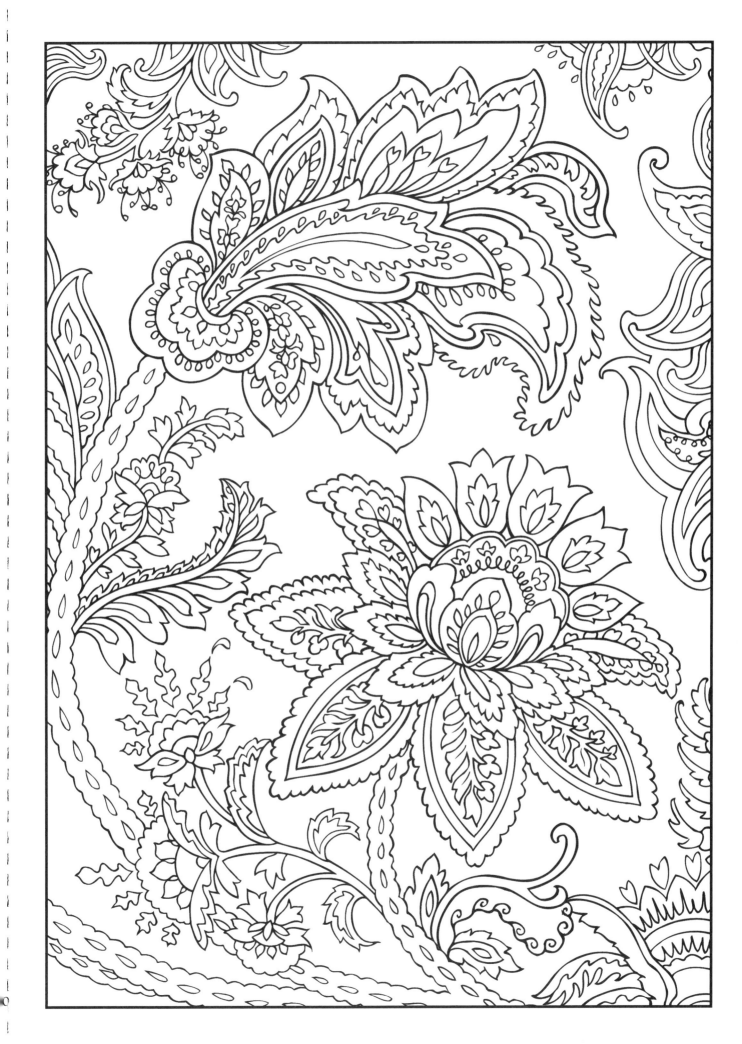

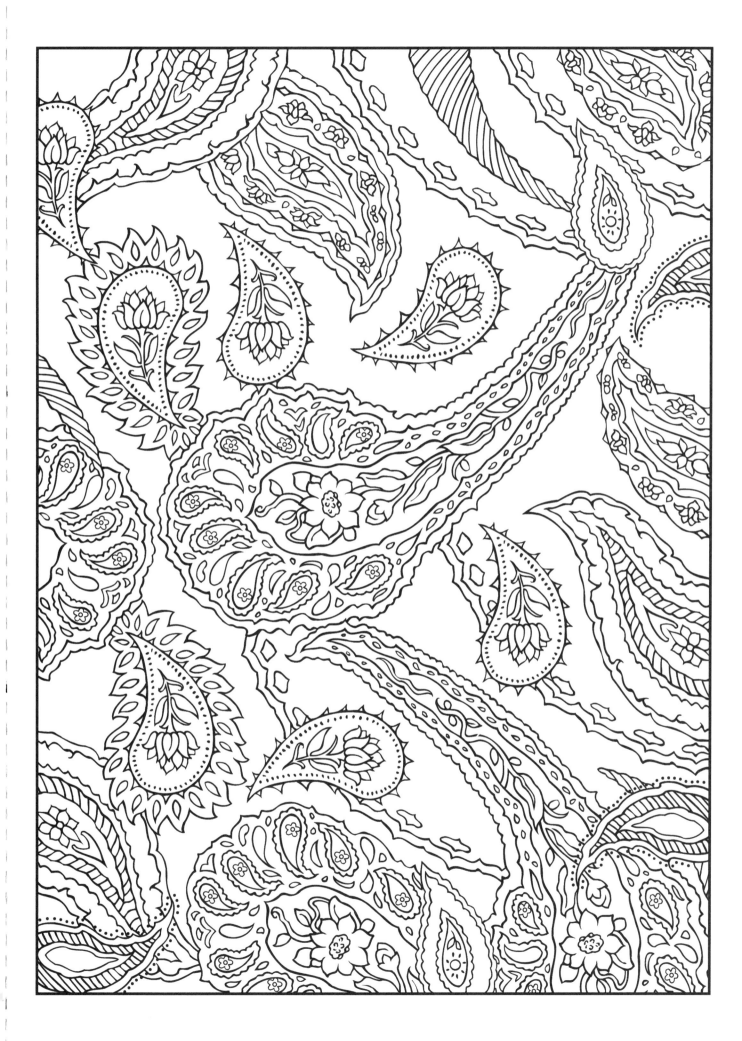

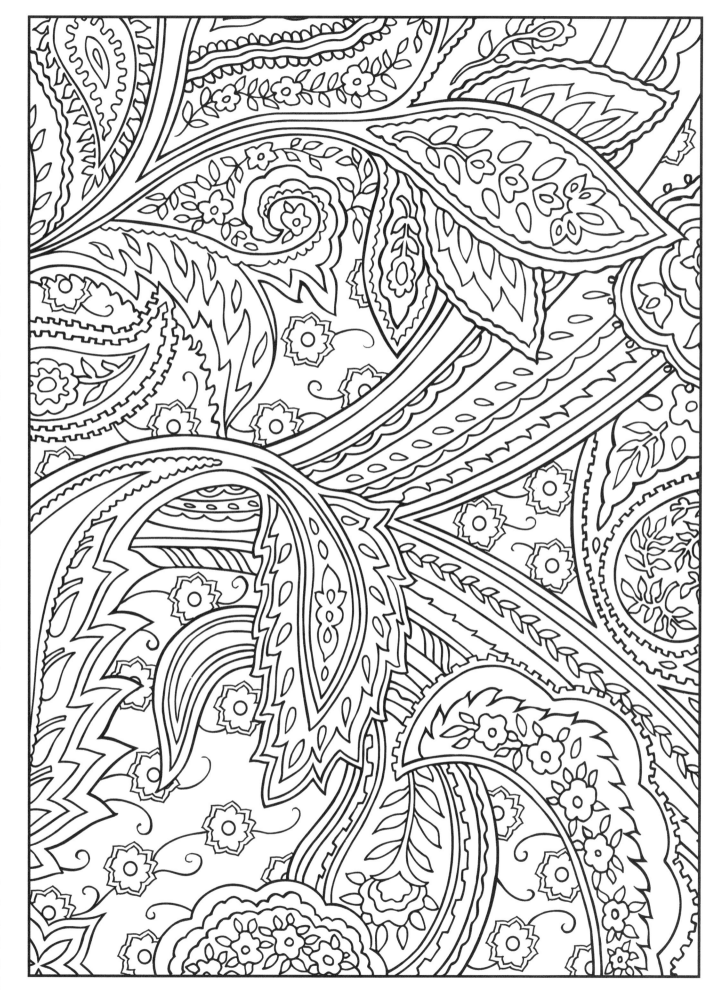

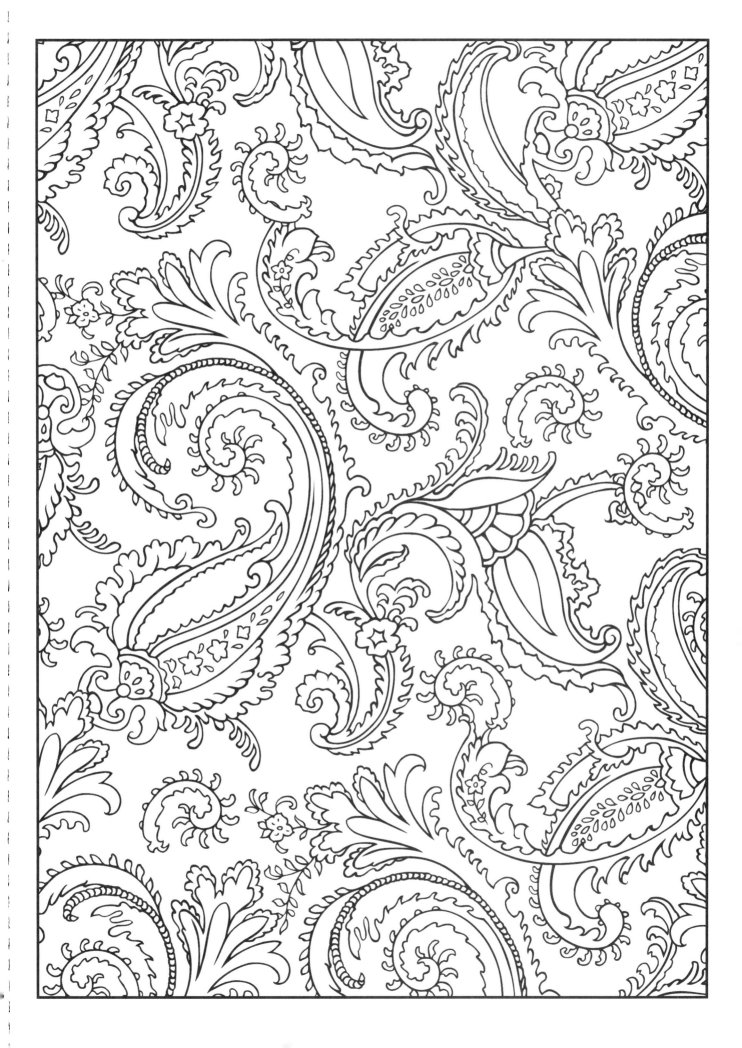